TRUTH *and* PHOTOGRAPHY

TRUTH
and
PHOTOGRAPHY

Notes on Looking and Photographing

JERRY L. THOMPSON

Chicago
IVAN R. DEE
2003

Walker Evans photographs copyright © Walker Evans Archive, The Metropolitan
Museum of Art, used by permission. "Truth and Photography" and "Thinking and
Feeling" were published in slightly different form in *The Yale Review*.
Quotations from Wallace Stevens are from *The Collected Poems of Wallace Stevens*,
copyright © 1954 by Wallace Stevens, renewed by Holly Stevens. Used by
permission of Alfred A. Knopf, a division of Random House, Inc. "In Praise of
Limestone" copyright © 1951 by W. H. Auden, from *Collected Poems* by
W. H. Auden, used by permission of Random House, Inc.

Library of Congress Cataloging-in-Publication Data:
Thompson, Jerry L.
 Truth and photography : notes on looking and photographing / Jerry L.
Thompson.
 p. cm.
 Includes bibliographical references and index.
 ISBN 1-56663-539-X (alk. paper)
 1. Photography—Philosophy. 2. Photography, Artistic—Philosophy.
3. Realism in art. I. Title.

TR183.T475 2003
770'.1—dc21 2003048475

For Marcia and Lydia

Introduction 3

Truth and Photography 17

Thinking and Feeling 49

The Light on Eighth Street 109

Afterword 165

Index 167

Photographs follow page 100

For you are not pale because we think truly that

you are pale, but rather it is because you are

pale that we who say so speak the truth.

—Aristotle, *Metaphysics* IX, 10

(translated by Joe Sachs)

TRUTH *and* PHOTOGRAPHY

Introduction

PICTURES MADE BY A LENS are inextricably linked to the real world. Lenses project images—visual representations composed of *the actual light* reflected from *the actual things* of which the lens has an unobstructed view. Photographs are images turned into pictures.

Photography was born of the union between two separate lines of technological inquiry. One line of investigation concerned optics and began with the camera obscura, a viewing device known since the Renaissance. Initially it was, literally, a *dark room*, one with a small opening through one wall. Since light travels in a straight line, the daylight scene outside projects its inverted, reversed image upon the wall opposite the opening. Improvements such as glass lenses and ground-glass viewing screens led, by the late nineteenth century, to a small portable viewing box able to convert a view of the world into a flat, picturelike projection.

The other line of inquiry concerned the chemistry of light-sensitive compounds. It had long been known that light causes certain substances to change color over time. By the early 1800s, attempts to reproduce a stenciled pattern by placing it over a light-sensitive material and exposing it to sunlight had been at least partially successful. The

main difficulty presented itself when the stencil was removed: the rest of the material continued to darken until the pattern was no longer visible. Another difficulty was that the photochemical reaction requires a great deal of light and tends to occur rather slowly, making its use with the faint images a camera obscura could produce problematic.

Many sensed, however, that the combination of optics and chemistry might somehow be made to work, and the technologists of that optimistic age—amateur as well as professional—set to work on a way that would allow focused light to draw its own image. As the historian of photography Beaumont Newhall put it, "The fever for reality was running high."

William Henry Fox Talbot of England and Louis Jacques Mandé Daguerre of France announced their successful processes in the same year, 1839. Their methods were different—Daguerre's produced a reflective silver plate, a negative which when viewed under the proper conditions read as a luminous positive; Talbot's produced a paper negative, which was then rephotographed, or printed, to produce a positive image on paper, viewable in ordinary open light as a drawing is viewable. Both procedures solved the central problems. The light-sensitive material (when *exposure* was augmented by the subsequent process of *development*) was responsive enough to record the faint image produced by the camera obscura, and the resulting image could be viewed in daylight without fading or darkening.

Once the process was able to produce consistent results, photography—like other technologies—soon found applications beyond anything the discoverers had imagined. What had been sought was a shortcut to the "Royal Road to Drawing"—a way to save artists the time spent learning to draw in the first place, as well as the time needed to make the many lines and marks of which a detailed image is composed. The detailed picture of the façade of St. Mark's Basilica in Venice requested by John Ruskin cost its maker six hundred days of work. Compared to this, the hour or two needed to set up the appara-

tus, make the exposure, and process the negative or plate was a miraculous advance. Instead of making a hundred pictures or even a thousand, one artist might now make a hundred thousand during a lifetime of work.

But speed was not all that was gained. As Talbot observed in an essay in the first published book of photographs (*The Pencil of Nature*, 1844), photography could not only quickly do what the artist wanted, it could just as quickly do *more*. One of the pictures Talbot reproduced was of the gateway of Queen's College, Oxford. In the brief essay appearing on the page opposite he notes that

> It frequently happens . . . —and this is one of the charms of photography—that the operator himself discovers on examination, perhaps long afterwards, that he has depicted many things he had no notion of at the time. Sometimes inscriptions and dates are found upon the buildings, or printed placards most irrelevant, are discovered upon their walls: sometimes a distant dial-plate is seen, and upon it— unconsciously recorded—the hour of the day at which the view was taken.

A tiny detail which had escaped the artist's attention was there to be seen, included in his picture even though the artist had not seen it and had not allowed for it in his design.

Previously a critical viewer of a picture might complain that some feature of a view had been poorly drawn, or *left out*. In a photogenic drawing—a drawing made by the light itself—not only was the drawing perfect, but extra features, things the artist failed to notice, were *left in*. Instead of starting with a blank page, the photographic picture-maker started with everything before his lens, the whole visible world. Talbot's observation in this brief essay (one of the first nontechnical essays on photography) opened a new window onto this visible world. Now, he understood, it was possible to make a record of visible reality not limited by the patience, skill, and understanding of the maker, a

5

record not filtered through the habits of his trained hand, his eye, and his visual memory. The photogenic process recorded everything—the idiosyncratic, the fortuitous, and the anomalous along with the coherent overall pattern intended by the artist.

The brief essay recording Talbot's enthusiasm for "objective" record was published in 1844. By this date many English writers and thinkers had embraced the new "subjective" philosophy imported from Germany by Samuel Taylor Coleridge and others, the much-discussed change in the mind of the West generally known as Romanticism. "[W]e receive but what we give,/ And in our life alone does Nature live," wrote Coleridge in 1802, in a poem stressing how the thoughts and moods of the individual self shape and color—*form*, as he would later say—the world that self sees. Already in 1799 his friend William Wordsworth had written of "[a]n auxiliar light" that came from his mind—a light of his own, a light in addition to Nature's light. His was a mind which was "creator and receiver both,/ Working but in alliance with the works/ Which it beholds"—a mind working *in alliance*, as an active contributor, not a passive receiver, a mere mirror of nature. By 1833, the date of "What Is Poetry?," John Stuart Mill could answer the title question of his essay by stating what by then was obvious: "Descriptive poetry consists, no doubt, in description, but in description of things as they appear, not as they *are*." These writers were interested not in the "objective" world so much as in the individual self's construction of it. The artist's response to a scene was what mattered. *Art* was this response to the scene, not a mere record of its appearance.

Others of Talbot's essays in *The Pencil of Nature* reflect this current thinking. He includes in his book of photographs two separate views of the same sculpture (a bust of Patroclus). In the essay opposite the first view, Talbot makes this observation about photographs of sculpture:

6

These delineations are susceptible of an almost unlimited variety: since in the first place, a statue may be placed in any position with regard to the sun, either directly opposite to it, or at any angle: the directness or obliquity of the illumination causing of course an immense difference in the effect. And when a choice has been made of the direction in which the sun's rays shall fall, the statue may then be turned round on its pedestal, which produces a second set of variations no less considerable than the first. And when to this is added the change of size which is produced in the image by bringing the Camera Obscura nearer to the statue or removing further off, it becomes evident how very great a number of effects may be obtained from a single specimen of sculpture.

Rather than an embodiment of some absolute objective record of things as they *are*, the photograph is a *view*, a view taken from a single point in space—a *point of view*. It shows things as they *appear*, not as they "are": different views of *the same thing* have different *effects* on the viewer. In this essay (and in others as well) we notice Talbot's enthusiasm for the artist's control over his vision, his manipulation of the elements of seeing, and the choice among alternatives available to him as he decides where to take his view from: as he exercises his "subjectivity." We note this enthusiasm as much as we note his interest in the richness of unexpected detail, in the "objective" description of the gateway of Queen's College.

The divided enthusiasm of Talbot's essays foreshadows the next 150 years of photographic practice. By the end of the 1800s a majority of well-known serious photographers would be "expressive"—rather than descriptive, or "documentary"—artists. Edward Steichen attached a vibrating motor to his large camera to obliterate fine details in his pictures of such subjects as moonlit wooded pools. He wanted the *feeling* of the light, the suppressed tonalities, a general sense of place, above

all the *mood* of the scene, not precise topographical or botanical description. He and other camera-artists of the period made their pictures look like paintings or etchings. Some gathered in salons to show fuzzy moonlit views, portraits and groups of idealized or allegorical figures, carefully composed genre scenes. Their goal was *the beautiful*—a quality that resides in the viewer and not in the thing viewed, as Kant had taken great care to point out—and their intentions differed little from those of contemporaneous artists who drew, painted, or sculpted.

Twenty years into the new century, reactions set in. Salons were replaced by revolutionary groups like *F64*, named for the small aperture of the lens diaphragm selected to produce a maximum of clearly focused detail. Urgently worded credos announced the importance, even necessity, of sharp-focus images printed on shiny-surface commercial printing paper from large negatives. These were touted as true while the muddy tonalities, blurred outlines, and rich matte surfaces characteristic of pictorialist prints were denounced as false, dishonest. The new style recorded what Edward Weston (who had begun as a soft-focus pictorialist) called "the stark beauty that a lens can so exactly render."

But though they had the look of objective fact, these samplings of the world were in fact selective and directed by ambitions easily recognizable as artistic. Another sharp-focus photographer, Walker Evans, carefully distinguished between *straight* documents—police photographs, say—which were not art, and documentary-*style* pictures—personal poetry disguised as prosaic fact—which were. A picture might look like a mug shot or a photograph hung in the window of a real estate office, but—if its maker had a mind, an eye, and sufficient taste—it could be a work of art.

In the fifties and sixties of the last century, smaller cameras came into wider use, and the fascination with unlimited detail began to fade for a second time. For many, though, the texture of reality remained

important, even in the absence of hyperdetailed facticity. The small-camera pictures of Robert Frank (published as *The Americans*, 1959) depend not so much on fine detail as upon adequate description; they are especially alert to gesture, juxtaposition, and context. A white baby is held by a black nanny who wears a white uniform on a blazingly bright white street; a dark face in a darkened barroom takes the false light of an electric jukebox as a bubble of daylight explodes from outside the world of this picture through the round window of a door in the background; a tiny solitary figure trudges along an urban street rendered in dark greys in the direction indicated by a neon arrow above his head, a bright commercial sign the figure does not notice, though its fiendish imperative dominates the picture. These grainy, starkly black-and-white pictures have the appearance and conviction of raw truth, but they present not so much *grim reality* as *reality grimly seen*. These gestures and juxtapositions—among many others—were available, but it was Frank who selected and seized the moments, framed and printed the views, and chose the pictures to be included in the sequence of his book, which is at once a shout of protest and a cry of pain (as well as a successful and massively influential work of art).

By the early 1970s serious young photographers were again developing an appetite for a wealth of detail to be presented to the viewers of their pictures as *immediate* visual experience—a visual experience unmediated, or mediated as little as possible, by any recognizable artistic or conceptual strategy. In a photograph by Robert Adams, a tract house sits in the merciless Colorado sunlight, a simple fact simply described, its significance and implications intimated perhaps, but not expressly set out in a rhetorical structure traceable in the picture's design. Large cameras (or smaller cameras used so carefully the pictures look as if they had come from larger cameras) came back into favor, encouraged perhaps by museum shows and books presenting the photographs of nineteenth-century photographers such as Mathew Brady, William Henry Jackson, and Timothy J. O'Sullivan, whose intentions

were more documentary than *artistic*, as that term was understood in the late nineteenth century.

From photography's beginning, a penchant for subjective understanding has coexisted with the urge to present objective description. At any single moment in photography's history, one of these two impulses may be understood to dominate the other, but one rarely appears unshaded by the other, and at any one time the consensus among photographers has never been complete. Eugène Atget was making clear, sharp-focus descriptive views of Paris while Steichen was photographing murky moonlit pools; Ralph Steiner was photographing automobiles and painted storefronts the same year and only a few miles distant from the place where Alfred Steiglitz was photographing clouds. In 1976 the Eakins Press published a collection of photographs by Lee Friedlander called *The American Monument*. The monuments in this survey are public, but Friedlander's views of them are as stubbornly personal as an improvised jazz solo: quirky, unexpectedly funny or lyrical, and relentlessly inventive. The book's epigraph is from Whitman:

> All doctrines, all politics and civilization, exurge from you,
> All sculpture and monuments, and anything inscribed anywhere,
> are tallied in you,
> The gist of histories and statistics as far back as the records reach,
> is in you this hour, and myths and tales the same,
> If you were not breathing and walking here, where would they all
> be?

About the same time (in 1973) a young but directed Nicholas Nixon could write of the graduate art program in which he was enrolled:

> Everyone here is interested in the photographer as a maker of
> tours de force mainly with the stamp of art (and the maker), and I am
> more interested in what's out there in front of the lens.

WHETHER subjectivist or objectivist in temperament, the most thought-provoking photographers have used photography not just as a set of tools for generating images but as a distinct medium. By *medium* I intend to suggest a means of mediating a significant connection with the world. We say of a writer that language is his or her medium; we mean that this artist *finds his way* by using words. He may have an intuition or a feeling about things, but he works toward an understanding and expressed account of this intuition or feeling by using words. He gets to know words intimately, understands their nuances, close distinctions, and shades of meaning. He approaches that intuition or feeling by putting words together into sentences and paragraphs that sometimes express just what he had in mind initially, and sometimes, as the meaning of the writing is clarified and resolved, lead him to say something other than what he initially intended. In the end, the finished writing gives an account of a particular human experience of a specific historical moment.

Similarly, photography can serve as a medium. Photographers use *things they see* and the *elements of seeing* instead of *words* and *grammar*. They use the act of photographing the world—the photographic encounter—as a means of finding their way or understanding the world. They arrive at understanding by photographing. Think of Timothy O'Sullivan's well-known photograph of the south side of Inscription Rock, made in 1873. A close detail rather than a view, this picture, in examining a few square yards of almost-flat desert rock, also presents an understanding of its subject. The view shows an ancient Spanish inscription, written in serifed letters with elegant swag-bellied *d*'s and *a*'s, letters which at once describe and display something of the quaint character of a bewildered and eventually failed attempt to chart a huge hostile land. It also shows a bluff Anglo-American measuring stick—an English yard marked off in bold block numbers, white against black laid upon the muted greyness of desert terrain. Some of the scraggly

flora has been cut away and enlisted to hold the yardstick level, parallel to the lines of script and to the picture's edge, in a blunt make-do arrangement implying the force and hard efficiency of an enterprise which will not fail. (It didn't; the survey O'Sullivan worked for mapped the route for the railways that changed the West from wilderness to suburb.) In going about his job, O'Sullivan has taken the old and the new, the natural and the man-made, the quaint and the blunt—taken all this in the stride of his forceful energetic march across a strange continent, taken all this and forged it into a picture that presents a new understanding of what that landscape is, and what it means.

When operating in this most ambitious mode, as a true medium, photography is concerned more with *meaning* in the largest sense than with visual design or style. Any single photographer, while at work, may be consciously thinking *only* of how this shape, this tonality, fits with some other, or not be conscious of thinking at all about what he or she is doing. But if his work grows out of an established, legitimate, and refined connection to the world he walks through—the world he sees, knows, and experiences—meaning comes to reside in the finished work *as if through its own agency*, as the tiny unexpected details described by Talbot came to reside in his finished prints.

The quality of this connection, this relation to the world, is crucial, and is probably determined by temperament rather than by conscious choice (though certainly any kind of connection, once recognized, can be cultivated). At one extreme is the disembodied tasteful eye that sees only, the connoisseur of pure form. Such an eye is trapped forever on the surfaces of things, unable to penetrate beyond thin superficial charm. At the other extreme is the pure thinker, a mind so occupied with *meaning* and its consequences that the mere *look* of things counts not at all and cannot affect the shape of ideas forming of their own internal momentum. Somewhere between these extremes lies the kind of connection to the world favorable to the practice of photography as a medium.

Coleridge's definition of *imagination* (as distinguished from *fancy*) comes to mind, and seems to apply. Fancy plays with fixities and knowns—ideas and substances whose common understanding is unquestioned—recombining and juxtaposing them in decorative arrangement, as a designer might rearrange colored tiles in various patterns, or a versifier the sounds and accepted meanings of words into palatable, accessible, useful sentiments. The ends of fancy are pleasure and reassurance. Its effect is described (and savaged) by Vladimir Nabokov's arch retranslation of the first line of Keats's *Endymion* from Russian back into English:

A pretty bauble always gladdens us.

Imagination, on the other hand, is forever seeking to incorporate new ideas and experiences, reaching toward a new, larger whole. Its end is understanding. Its accomplishment is described by T. S. Eliot (in a 1922 review of an anthology of poems by the metaphysical poets):

Tennyson and Browning are poets, and they think; but they do not feel their thought as immediately as the odor of a rose. A thought to Donne was an experience; it modified his sensibility. When a poet's mind is perfectly equipped for his work, it is constantly amalgamating disparate experience; the ordinary man's experience is chaotic, irregular, fragmentary. The latter falls in love, or reads Spinoza, and these two experiences have nothing to do with each other, or with the noise of the typewriter or the smell of cooking; in the mind of the poet these experiences are always forming new wholes.

When a photographer's mind is perfectly equipped for his or her work, it is constantly making connections not only among the shapes it sees but among the things it encounters and their significances, and to the whole range of human thought and culture to which these significant things allude.

TO A WORKING PHOTOGRAPHER, the practice of photography is repetitive and athletic, enlisting eyes, fingers, and other body parts in regular, routine exercise. Picture-taking becomes a nearly automatic reflex for a regular practitioner, a response so quick, so oft-repeated as to seem purely instinctive and not thoughtfully deliberate. In 1964—to take an extreme example—Garry Winogrand, looking out the window of a moving automobile, snapped a picture of a tiny running figure, caught in perfectly drawn mid-stride and also neatly framed between the two diagonal support cables attached to a telephone pole near the road's edge, between photographer and runner. What kind of deliberate thought could lead to such a picture?

In geometry it is axiomatic that two points determine a straight line. In order to make *this* picture the photographer had to find a straight line (his line of sight) through *three* points—the car's window, the space between the two cables, and the running figure—two of which were moving, and one of which (the running figure) was constantly and rapidly altering its shape. The figure's fleeting, calligraphic gesture could have been caught between the cables only during an instant lasting no more than a few thousandths of a second. The photographer barely had enough time to press the shutter release, let alone think.

Yet photographs *provoke* thought, many of them a great deal of thought. They give us matter for thinking because they combine a convincingly real image of the world with a measure of control resembling the shaping power we take as evidence of artistic vision. Photographs are part undeniable reality: since 1842 the word *photographic* has been used to denote the ultimate degree of truth. But they are also part personal vision: they involve selection and interpretation. This mixed state of affairs, this marriage of the public and the private, provokes thinking not only from those who look at photographs but also from some of us who make them.

INTRODUCTION

These essays are a working photographer's attempt to sort out the elements of this complex state of affairs, or at least to sort out my own thinking about photography and photographs—*sort out* in the sense of identifying what ideas are in play when I look and think about what I see. When (as a viewer) I look at a picture, what am I seeing and thinking? When (as a photographer) I look at a subject, what am I seeing? Thinking? Doing? What is the essence of what happens when a photograph is made?

I hope my attempts at understanding do not leave the reader with settled, "definitive" readings of the photographs I discuss. *Looking*—at old pictures as well as at the present-day world—provokes *living thinking*, not reductive analysis tending toward a single, final explanation. An extraordinary richness of reference, allusion, and association is engaged when a photograph understands a scene and a viewer in turn understands that photograph. This richness of connection is what makes photographs (for me at least) the most intriguing, the most *thought-provoking* type of image humankind has troubled to learn how to make.

Truth and Photography

I fear those big words that make us so unhappy," Stephen Dedalus is given an opportunity to say early in the novel *Ulysses*. *Big* words? Such a clever lad could hardly mean to refer to words that are hard to spell or say. His smug superior, Mr. Deasy, has just used the words *generous* and *just* in the same sentence, and Stephen is clearly thinking of words whose *large meanings* make us squirm. Of these, few are bigger—or more freely used—than the simple word *truth*.

Because of the particular abilities of their tools and materials, photographers tend to talk a lot about *truth*, usually without trying to explain what they might mean by the word. Big words like *truth* have meanings that are slippery and hard to pin down; only by taking some care in their use (and in the use of other words and ideas linked to them) can we hope to get beyond fuzzy first impressions, the loose invocation of approximate meaning that Stephen rightly fears. In this essay I intend to set my thoughts on this subject in some order. By referring to a small number of pictures, I hope to be able to say something about what *truth* and *photography* may have in common. I intend to proceed step by step, with a degree of care that may on occasion try the reader's patience but will, I hope, allow a measure of success in identifying some of the *ideas* that attach to the practice of photography.

Even the technical word *photography* can be understood variously: the word can refer to the processes and procedures used to make a photograph, to the practice of these, or to the body of work accumulated during the time since photography began to yield results.

As a body of work, photography has been the receptacle for contributions from several different sources, traditions of thought and practice each having its own independent history. Initially scientists and technologists contributed the optical and chemical researches that made the process of photography possible. For them, an *improvement* would be any advance (such as a new lens design or a film coating that was more sensitive to light) that could make the process work better.

Soon workers with other concerns joined these technicians. Historians (or at least entrepreneurs and popularizers interested in history) wanted to use the new medium to record the likenesses of great men and the settings for great events. Natural scientists wanted accurate, detailed views of the moon and the nebulae, of biological specimens, of exotic forms of human life. Journalists wanted pictures of real events, made instantaneously, as the events unfolded. These practitioners of photography brought their own needs and goals to the developing new medium. For any one of them, *improvement* would be any change in the use of the medium that resulted in pictures more suited to his particular needs: the snapshot for news photographers, say, or the long time exposure guided by a clock-regulated tracking mechanism for astronomers. Photography, both as a practice and a rapidly accumulating body of work, quickly came to mean different things to different people. Only the basic tools, materials, and procedures were the same for all workers.

Artists also took up the new means of producing pictures, adding their accomplishments to the growing body of varied work known as *photography*. Within the first decade of practice, thousands of portraits—many of which still exist—were produced by "Daguerrean artists" of all levels of ambition and competence. When the negative-positive process came into general use, photographers made not only large numbers of pictures but also large numbers of prints of their successful images. By the 1860s America was awash in photographs, and

the term *photographic* had entered the language as a measure of ac-
curate verisimilitude.

For these early workers, verisimilitude equaled truth. For them,
truth in a photograph meant that the picture *looked* exactly like a view
seen from the camera's exact position (with one eye closed). Color of
course was absent, but the aspects of individual things, their over-
lappings and recession in space, and the minute details visible on their
surfaces (looking at photographs, especially daguerreotypes, through a
magnifying lens seems to have been popular)—these things were all
recorded, even if they had not been noticed by the camera operator at
the time of exposure.

For sophisticated visual artists, this indiscriminate record was in-
convenient. It worked against the urge to shape, to streamline, to form
into meaning. Artists who wished to produce, say, historical allegory or
a biblical scene found an excess of specific detail distracting. How
could the artist expect his viewer to admire the sublime nature of
Christ's divinity if the viewer were forever noticing a chipped or dirty
fingernail, an unfortunate bump in the bridge of the nose, a crooked
tooth, or the fixed stare of a frozen model?

Other viewers were astonished by pictures containing unlimited
detail, captured within a few seconds, as if by magic. Poe noted in 1840
that "the daguerreotyped plate is infinitely (we use the term advisedly)
is *infinitely* more accurate in its representation than any painting by
human hands . . . the closest scrutiny of the photogenic drawing dis-
closes only a more absolute truth, a more perfect identity of aspect
with the thing represented." *Identity of aspect* was a truth Edgar Allan
Poe, for one, was willing to consider with admiration.

It took a while for sophisticated visual artists to share in this enthu-
siasm. By 1900 many of the recognized artists who had taken up pho-
tography—Edward Steichen, for example—were fuzzing their focus
soft, or working on negatives and prints by hand to eliminate unwanted

specificity of detail. The "truth"—the accurate verisimilitude—admired by the early workers was a truth too literal for their tastes.

By the end of the nineteenth century another notion of truth had entered the ragtag body of theory dragged along by the many-faced (and rapidly diversifying) practice of photography: *artistic expression* became a goal of truth-seekers. The artist, in regarding a scene, is affected by it and has a *response*—an emotion—that he may or may not be able to name but can *express* through his rendition of the scene. Faithful expression of a strongly felt response was thought of as a kind of truth.

The notion of artistic expression is a Romantic idea, and it presupposes what Descartes was the first (in the modern era) to propose with force and clarity: that *knowing the world* involves two necessary components, a thinking, perceiving *subject*, and a perceived, thought-about *object*. The *subject* sees, touches, holds, turns—receives sense impressions he combines *in his thinking self* and thus *knows*, or experiences; what he knows is the *object* (which may or may not have existence independent of the knowing subject). The quality or timbre of the subject's experience (of a sunset, of a face, of whatever) is *what the artist expresses*.

With this model in mind, *truth* begins to mean something a little different. Truth in photography *may* involve some degree of verisimilitude to the object seen, but the primary reference shifts from object to subject. *Truth* now refers not to accurate representation of the object seen but rather to accurate representation of the artist's response to the object or view. *Truth* now means fidelity to the subjective experience of the artist.

This, it must be clear, is a major shift. The earliest workers were concerned with copying a thing, a view; now another element—the response of the perceiving subject—is inserted, and this *subjective response* becomes the "thing" to which the photograph is "true." *Truth* now means something like *correspondence*: a statement or expression

contained in a picture *corresponds to* the artist's experience of an object (a thing or view) in the world. Presumably a sympathetic viewer, looking at the print, will "feel" something like what the photographer "felt" when looking at the scene.

It is important to note that truth as *correspondence* is not necessarily incompatible with truth as *verisimilitude* (that is, to the scene photographed), though it took a while before anyone tried to unite the two sets of concerns. Early workers tended not to occupy themselves with subjective response, and visual artists of a Romantic bent tended to have less appetite for complete, indiscriminately detailed records. Alfred Stieglitz was one of the first to see (and certainly *the* first to argue and advertise) that detailed, truly *photographic* pictures and artistic self-expression belonged together.

By 1920 Stieglitz was consistently making detailed images in hard focus from near to far, often on large 8x10-inch negatives printed on commercial paper in a tonal scale suggestive of normal daylight vision. The verisimilitude of these pictures (if not the objects in the frame, or the manner of framing) would have satisfied the most demanding early worker, yet Stieglitz felt they also met his standards of self-expression, which were high.

His friend and supporter Ananda Coomaraswamy, writing in 1924, described Stieglitz's accomplishment with admirable clarity:

> Mr. Stieglitz' work well illustrates the fundamental problems of the photographer. The camera is a means of expression with virtues and limitations of its own; the photograph which looks like a drawing, etching or painting, is not a real photograph. The peculiar virtue of photography, and at the same time, in the hands of a purely mechanical operator, its severest limitation, is its power of revealing all textures and revealing all details. The art of photography is to be sought precisely at this point: it lies in using this technical perfection in such a way that every element shall hold its place and every detail con-

tribute to the expression of the theme. Just as in other arts there is no room here for the non-essential. Inasmuch as the lens does not in the same way as the pencil lend itself to the elimination of elements, the problem is so to render every element that it becomes essential; and, inasmuch as in the last analysis there are no distinctions in Nature of significant and insignificant, the pursuit of this ideal is theoretically justified. A search for and approach to this end distinguishes the work of Alfred Stieglitz.

Accurate verisimilitude is photography's richest harvest; an artist of Stieglitz's caliber makes use of the whole harvest, eliminating nothing, enlisting all as elements essential to "the expression of the theme."

Stieglitz himself, writing in 1921 of an exhibition of his own photographs, says a little more about the "theme" that his work "expresses":

> The Exhibition is photographic throughout.... Every print I make, even from one negative, is a new experience, a new problem. For, unless I am able to vary—add—I am not interested.... I was born in Hoboken. I am an American. Photography is my passion. The search for Truth my obsession.

His "theme" is truth; the search for its expression involves passion, and this truth-seeking is intimately tied up with his *experience*, which grows and changes. And his is a *particular* experience, one that has to do with being American, he says here (though sentiments aroused by the recent war may have encouraged him to stress his freedom from German influence); the pictures themselves, in their preference of the private, the close, and the partial, are as personal—as specifically about his particular experience—as lyric poetry.

A look at a late picture may show something about Stieglitz's search for truth. *Porch with Grape Vine, Lake George, 1934*, a gelatin-silver (commercial paper) contact print made from an 8x10-inch negative, shows an oblique view of a portion of well-maintained clapboard

wall, windows, shutters, part of a wooden porch, and bits of its over-hanging roof along with one ornamented supporting column. The camera is so close to the house that the view shows mainly pieces of things; only one window and the column supporting the porch roof are shown entire.

Clearly the *truth* sought and shown here is not information about the wooden house, its style or significance. An early worker in photog-raphy might admire the degree of verisimilitude—though the camera is close, everything from the nearest porch rail to the plantings on the other side of the house are in clear focus, and the tonal distinctions among the various substances and planes are rendered with great clar-ity; even the brightest face of the turned porch column is distinct from the white clapboard behind it, and the dark mass of grape leaves seems to have volume and depth. There is even a hint of visible structure in the dark underside of the porch roof on the right side of the picture.

However much he might admire the *degree* of verisimilitude, the early worker might be disappointed by the picture's failure to present a portraitlike likeness or tell anything readily understandable about the identity or use of the structure it shows. By 1934 Stieglitz, at seventy, was far beyond such pedestrian concerns, and his *truth* no longer in-volves *completeness* in a literal sense: he feels no responsibility to give the informational account that an average viewer of photographs might expect. His *truth* involves a completeness of another kind: a completeness that includes a convincing sense of the physical pres-ence (if not a whole view) of the thing photographed, and also the artist's experience of the picture occasion.

Stieglitz described his late cloud pictures as "direct revelations of a man's world in the sky." The word *equivalent* has been attached to these pictures, suggesting that they are equivalent to, can stand in place of and represent, the artist's "experience"—his response and emotional state. This 1934 picture amounts to the direct revelation of a man's world *on the earth.*

It shows familiar territory—a house he knew well, the Farmhouse, the main dwelling (after 1919) on the Stieglitz property on Bolton Road in Lake George, New York. The structure is observed from close up, one might say intimately, yet with a preciseness that is considerable, and sophisticated. Tiny perfections coincide, due to careful placement not just of the camera but the camera's lens (the exact point of which, the pinhole opening of its stopped-down diaphragm, determines over-lappings and juxtapositions). Stieglitz has placed the lens just so far back, choosing between a little to the left and a little to the right, so that the round porch column is barely contained by the contrasting edge of the dark shutter, *and* the round shade-pull visible in the dark window is backlighted by the cropped bright opening of the window on the other side of the house. This coincidence by itself determines both the distance and the lateral placement of the lens: no other posi-tion would show both juxtapositions. A little exploration up or down could be managed while still preserving these two juxtapositions, but vertical movement is locked by another alignment: Stieglitz has con-trived to fit the three bands turned onto the porch column nearly ex-actly into the width of a single clapboard. Only one lens position will project onto the film the alignments this paragraph describes.

The lens on Stieglitz's camera could be moved up and down inde-pendently of the rest of the apparatus, allowing the top and bottom margins of the picture to be adjusted somewhat—a very little—*after* distance and lateral and vertical placement had been fixed. A tiny movement of the lens—no more than an inch either up or down—could adjust these margins without destroying the precise alignments already described. Within these narrow limits he managed the framing that clips the corner of a second-story window, introduces a trapezoid of white sky above the porch roof, and excerpts the capital of the porch column, at the same time admitting a piece of the porch (lower left) that answers, in terms of visual weight, the white trapezoid of sky and

dark shadow in one corner, the (visually) active capital in another, and the mass of grape leaves in a third.

With deliberate exactness Steiglitz has organized a composition that relegates the areas of greatest visual activity to the sides and corners of the picture and plays these areas off against each other so that they "balance." By choosing an arrangement that distributes visual interest toward the edges and corners of the picture rather than leaving it massed at the center (as in, say, a conventional portrait), Stieglitz acknowledges the modernist vision of the artists he knew and showed in his galleries, and helped introduce to this country. His tense, decentered picture salutes the "truth"—the new orthodoxy—of modern painting, of painters like Marin and Hartley whose pictures were not simply "of" something but rather were things in their own right, with importances of their own. In the work of a painter like Georgia O'Keeffe, what the picture was "of" was of course important, but equally important was how the space of the whole picture was filled up in a beautiful way, with lines and color and rhythmic pattern extending right out to the edges and corners.

All of this—the control, the careful attention to detail, the mastery of tonal rendering, the skill at "modern" composition—is part of Stieglitz, is part of what he brings to the scene and hence is part of the "truth" of this picture: the faithful account of his response to the occasion.

There is even more. Although visual interest extends to the corners and edges, the center is not left vacant. The *exact* center—where the picture's diagonals cross—is just to the right of the dark shutter's edge, seen against the contrasting white clapboards. The sawtooth shadow line of shutter against clapboard is just left of center, and the compelling dark mass of the window is shifted right of center—a shift that balances, visually, and thus honors the importance of the porch column shown whole on the far left.

Although displaced, the dark window is the emotional center of the picture, a dark vortex into which the light of the print sinks. It is an interior not shown but implied, a dark withdrawing from the daylight logic of the regular clapboards and orderly gingerbread ornament of the column's capital. At the heart of this constructed logic lies a dark receding mystery, a closed-off secret, a realm of shadow and quiet. Its blackness is an unanswerable rejoinder, a hole punched out of the luminous logic of the composition.

But this picture shows not only emotion-charged architecture, the neat oneiric house-as-metaphor described by Gaston Bachelard in *The Poetics of Space*. A fifth of the picture area (and a third of the picture's title) is given over to the grapevine, a dark, unruly organic mass extending from the lower right almost to the picture's center. Another planting appears on the far side of the house, its contour paralleling that of the grapevine, and beyond, in the far distance, a wooded hillside climbs almost to the porch roof's edge. A hazy mist thickens as distance recedes, casting the atmosphere of the picture as soft and moist.

The lush plant forms and the implied humidity add an additional element to the picture's "truth." If the Apollonian logic of the house's architecture (and the picture's structure) contrast with the dark, cool withdrawing of the shadowed interior, this contrast is softened, mollified somewhat, by the lush grapevine and soft light. As a sculpted vine softens the "Vine Angle" of the Doges' Palace in Venice (as described by John Ruskin), the grapevine here softens, and distracts from, the hard contrast of structure and darkness. Something having to do with seasonal growth — its inevitability, its softness, its lushness — invades the structure of the picture, bringing a note of affirmation (the vines that flourish, the soft wooded hills in the mists beyond) to a severe, gloomy meditation.

Even further, the collection of *things* chosen by this picture — the house fragment, the window, the porch pieces, the plantings — are able

to come together in the light-versus-dark picture Stieglitz has made because of another kind of renewal, an event in the artist's life that has made this picture possible. This pattern of things is photographable because light falls on the clapboards and porch, and daylight reaches these clapboards and this porch because a section of the porch roof was removed as part of Georgia O'Keeffe's campaign to brighten up the Lake George house.

O'Keeffe's appearance in New York and Stieglitz's precipitous decision to move into her studio resulted in a fury of photographic activity, including hundreds of portraits of O'Keeffe. By the end of World War I, Stieglitz, the Old Man, was beginning to be thought of as a part of history. But after he moved in with O'Keeffe he began to make new pictures, find new artists, start new galleries, sponsor publications. The pair eventually married, and Lake George came to be an important place for each and for them as a couple. O'Keeffe gardened and painted, Stieglitz photographed and worked in the darkroom, and the two lived as a happy couple during the odd seasons when the large and contentious troop of Stieglitz brothers, sisters, nieces, nephews, and attendants did not dominate the property.

O'Keeffe gradually made a place for herself at Lake George. She claimed and rebuilt an outbuilding where she could work without interruption, and ate her own kind of food independent of the Stieglitz family mealtime ritual. Walls were painted her favorite shade of light grey, and a portion of the porch roof was removed to let in more of the light that was so important to her.

By 1934 Stieglitz, who turned seventy on January 1, was nagged by recurring irregularities in his heartbeat, and he suffered bouts of angina. His arthritic hands ached in the cold water of his spring-fed Lake George darkroom, and his eyes bothered him. O'Keeffe had begun to spend months at a time in New Mexico, where she had bought property. She was not at Lake George as much, and their time

together in New York was filled with art-world events and people. He was distracted by the frequent appearance of ever-younger "muses" — nieces, grandnieces, and the steady parade of assistants and female supporters who sought him out at his galleries. Kitty, his only child from his first marriage, had been confined to an institution since the birth of her son.

Along with his 8x10-inch view camera, he dragged all this life's baggage out onto the lawn to look at the Farmhouse, settling on a portion of it that showed O'Keeffe's alteration. In the *Phaedo* of Plato, seventy-year-old Socrates demonstrates how the soul commands the body, rather than the other way around. On the day of this picture in the summer of 1934, Stieglitz commandeered his seventy-year-old eyes, ignoring his aches and fears, and peered at the dim glass to level the camera and align pillar with shutter, shade-pull with window light, column turnings with clapboard. Feeling the emotional as well as visual weights of light and dark masses, he set the picture's margins to adjust their balance. Precision of line, deployment of tone, response to the season, its humid air and its growth — these and other components, sensed but surely never named by Stieglitz himself (perhaps he thought of notes, even instrument sounds in orchestral music, possibly a German tone poem or song), settled into place, into an open, resonant structure, a structure responsive to his and the place's past, to their history.

All of Stieglitz is here. His will, his masterful ability, his artistic sophistication, his gloomy Romanticism, his age, his heroic refusal to give in to the inevitable — all are in this picture. As much as the sky pictures, this earthbound view is the "direct revelation of a man's world." The *truth* it contains is based on the accuracy of its grasp of the visible, physical reality — on its accurate report of the scene in front of the lens — but the larger Truth, greater than this, is the picture's fidelity, its correspondence, to Stieglitz's experience of life *as it was felt at the moment of the picture's making.*

30

ANOTHER PICTURE, made three years earlier a few dozen miles away, arrives at *truth* by a similar process, though the truth arrived at is radically different, and the photographer more different still. Walker Evans, forty years younger, had already met and even shown photographs to Stieglitz by the time he trained his 6-1/2 x 8-1/2-inch view camera on the main street (Broadway) of Saratoga Springs, New York. Although Evans later wrote and said a great deal about being an "artist," there can be little doubt, it seems to me, that he thought he was seeing truth as well as making art. By the end of his life Evans liked to cite Flaubert and Joyce as influences; in late interviews he often stressed the aesthetic detachment with which he regarded his subject matter. A year or two before he died he told a young English historian of photography he hoped to be remembered as a combination of Thoreau, Melville, Whitman, and Emerson—a pedigree as good as any American Studies graduate student could come up with.

However much Evans stressed his artistic lineage in later life, his writing *at the time of this picture*—not to mention other pictures he was making during the same period—suggests he had more than a passing interest in *truth*, though it was 1960 before he allowed himself to use that word in connection with his own work.

In 1931, the year of the Saratoga picture, Evans wrote a now oft-quoted review of several photography books for *Hound and Horn*, the literary and artistic magazine begun in imitation of T. S. Eliot's *Criterion* and edited by Lincoln Kirstein. In the space of ten paragraphs Evans gives a history of photography, dismisses Edward Steichen, notices German and French photographic anthologies, approves of August Sander, and more or less praises Eugène Atget. One sentence from his brief history lesson stands out:

> Suddenly there is a difference between a quaint evocation of the past, and an open window staring straight down a stack of decades.

Although ostensibly discussing the appearance of the modernist attitude in photography, which was to replace the pictorialist or late Romantic approach, he is without doubt glossing his own emerging style. This sentence catches the tone of the Saratoga picture perfectly.

The word *tone*, used in connection with Evans's work, has implications altogether different from those the word carries in a discussion of Stieglitz's work. With Stieglitz one thinks of the tonal scale, the careful distinctions between white and near white, opaque black and transparent near-black, or perhaps of the emotional weight of a certain luminosity. With Evans the word has a literary connotation. His tone is not something to be seen or felt but rather something to be *understood*: dry, hard, reserved, ironic, knowing, arch.

The *difference* Evans refers to in the sentence quoted—the something that is new—is what this view contains. The *old* is represented by *quaint evocation of the past*: three-syllable feet, soft consonant sounds give this description a prim, mincing sound. It describes genteel, etiolated work that refers, in a soft nostalgic way, to some past (possibly a Golden Age).

The first shot across the bow is the *Suddenly* at the paragraph's beginning. "[A]ctual experiments in time, . . . swift chance, disarray, wonder and experiment," a few words later, continue the breathless mood of urgency announced by *suddenly*, the very word which, followed by an ellipsis, ends a chapter of *St. Petersburg*, Andrey Biely's 1913 novel of revolution in Russia—a novel in which characters are distorted from human to mechanical and schematic shapes by the forces of rapid, uncontrollable change; a novel whose time structure is paced to the ticking of a bomb, a novel published in excerpt in *Hound and Horn*. *Suddenly* is a freighted, magic word, the alarm announcing that everything has changed.

The difference is between the *quaint evocation*, the genteel murmuring, and *an open window staring straight down a stack of decades*. One-and two-syllable feet march to a precipice and tumble straight

down, consonants clattering. The poetic form of the description sets the hard, dry, brisk tone of the—what? *Investigation* might be a good word; later in his *Hound and Horn* review, Evans uses the word *clinical*.

The view of Main Street is something akin to clinical. The intimate closeness and low position of Steiglitz's camera—his tripod legs were likely planted on the earth—contrasts with Evans's position, somewhat above it all (on a balcony, probably, the perspective imagined by the narrator of Stephen Crane's harrowing short story *The Open Boat*). *From above, from a distance* suggests detachment and removal rather than intimacy. The smooth tonalities Stieglitz coaxed from the roundness of the porch support are not evident in Evans's picture, nor is the soft, moist atmosphere: *airless* was the term Lincoln Kirstein chose to describe the merciless clarity of Evans's pictures.

In place of the lush grape leaves, this picture offers leafless elm trees and cast-iron floral gaslamps. The contrast of the elms' black limbs with the rain-slicked street is about as extreme as the materials allow, and the gaslamps are seen in near-silhouette against the sidewalks. The vegetal softening of Stieglitz (and Ruskin) is not a part of Evans's view.

Camera placement, so carefully determined in Stieglitz's view, is here deliberate but not as precise. The façades on the right are not exactly parallel to the edge of the plate, and a slight halo of flare creeps in from the plate's left edge: it is not clear exactly where the edge of the image should be drawn. The streetlamp on the lower left is not quite in but not decisively clipped, either. One suspects that some after-the-fact trimming will be needed to make this picture look as decisive as it seems to want to look. Evans in fact authorized more than one cropping of this picture, sometimes leaving the lower lamp out, sometimes in, sometimes leaving all of the bright sky above, sometimes closing in on the tree limbs.

Camera placement, though not precise, is *deliberate* in that the

camera is made to look up the street, between the rows of façades—and the rows of autos—lining it. This deliberate choice sees the building façades as foreshortened—seen from an angle, deprived of the foursquare frontal identity Evans explores in so many of his other pictures of buildings. Each side of the street becomes a hard-to-sort-out jumble of foreshortened columns and contrasting styles jammed up against each other, and the picture's center is yielded to a phalanx of diagonally parked autos.

The blackness of these vehicles suggests something of the blackness—the window—at the center of Stieglitz's picture, but the tonal composition is not as deliberately organized to maximize the effect. The street and buildings are blotchy, and the grass is dark, so the darkness of the cars is not as deliberately emphasized, as palpable as the darkness of the Lake George window.

The uniformity of the repeated shapes is what stands out, and this feature—the uniform repitition of a mechanical shape hostile to the ornate mess of the now antiquated façades—adds a note of black humor, of malignant glee completely absent from Stieglitz, not just from the Lake George picture of 1934 but from all of his work that I know. Evans's row of repetitive black cars in front of the hodgepodge of nineteenth-century façades manages to be menacing and funny at the same time—a little like the stalking black cat-figures in platform-soled jackboots that sometimes invade the cityscapes of Saul Steinberg. Imagine a fantasy palace of preposterous porticoes, huge four-story-high colonnades built in imitation of every resort known to (the American) man in his leisure, wealth, and boredom, the picture seems to say, and then imagine that a little while later some *other* leisured people decide to buy driving machines, all black and all shaped the same, and fill up the street in front of the palaces. Imagine the wicked amusement of such an observation and you begin to catch the arch, contrarian irony of Walker Evans in 1931. A concatenation of everyday things

can be beautiful, funny, tragic, ridiculous, and significant all at the same time.

Clearly, preciseness is not his main goal: *L'exactitude n'est pas la vérité* was Evans's choice of epigraph for his penultimate book, *Message from the Interior* (1966). For Evans, *exactness* is not *truth*. If not exactness, then what? He gives a hint, an oblique hint, as to what truth, for him, may have been.

The question of obliqueness, as it applies to Evans, requires a brief explanatory digression. Anyone with a broad knowledge of Evans's writings and conversation may be tempted to conclude that he is most revealing when he speaks obliquely. When he speaks directly about himself or his work, he is often exaggerating or distorting. Hilton Kramer has described this habit with admirable directness, both in his obituary essay in the *New York Times* ("Walker Evans, A Devious Giant of Photography") and in his introduction to James Mellow's biography, *Walker Evans*. It is when Evans praises or comments on the work of another that he is most likely telling something important about himself. A clear example of this trait can be found among the caption essays he wrote for the photographs he selected for *Quality: Its Image in the Arts* (edited by Louis Kronenberger, 1969). The last two are in color. One, by Marie Cosindas, has a respectful, appreciative caption. The other, listed as anonymous, draws a comment that is savage and dismissive.

Although not many in 1969 would have known, the "anonymous" picture—of a bright collection of haphazard signs—is certainly Evans's, and the caption essays for the two pictures have obviously been switched. A clever trick, worthy of Vladimir Nabokov (or Jonathan Swift), but a ploy that should serve as a warning to scholars eager to read Evans's many late, self-explanatory interviews too literally.

With this caution in mind, return to the oblique hint, cited above in the 1931 *Hound and Horn* review—a hint oblique because Evans is

writing about Atget's work. The care and force with which he makes his point suggest a broader application:

> [Atget's] general note is lyrical understanding of the street, trained observation of it, special feeling for patina, eye for revealing detail, over all of which is thrown a poetry which is not "the poetry of the street" or "the poetry of Paris," but the projection of Atget's person.

Truth for Evans, in 1931, is this *projection of his own person*; he projects himself by selecting and seizing a view. He *seizes* by deliberate camera placement and by delicate arrangement—an arrangement accomplished not by dragging the things around but by placing himself in relation to the everyday things the pictures show. What the pictures show is his view of those things.

It is a view consistently powerful and convincing. Those who admire his work often say they never really *saw* those things until he photographed them. They mean, of course, that they never saw the importance, the significance, the offbeat beauty of those things until they saw them *through Evans's eyes*. He shows the familiar world in a new way, through his deliberate, decisive seizing. This is the projection of his person; this is his *truth*: the world as you have never seen it before, the world as *he* saw it to be. Evans gives us the South/the thirties/America as Atget gives us Paris, as Joyce gives us Dublin. This is his truth—not the equivalent of his emotional experience, but his vision of "contemporary truth and reality."

Contemporary truth and reality: these are the words Walker Evans chose in 1960 to describe the aim of his work, though again the description is somewhat oblique. In 1931 he purported to be writing about photography in general, but in reality he was describing the work he hoped to do, was already doing then. In 1960 he wrote about work he proposed to do in the future, though in fact the work he describes had by then mostly been done. In a letter of April 29, 1960, to the Ford Foundation, in which he asked to be considered for its new fellowship

program for studies in the creative arts, he proposed a book of "docu-
mentary, non-artistic photographs . . . recording American society as it
looks today," and offered that he had "published one book, now out of
print [*American Photographs*], which points in the direction of this
work." He went on to say, "My book . . . aims at actuality in depth, and
at contemporary truth and reality. It may call attention to the serious-
ness in certain small things; it may reveal the emptiness in certain big
things."

After going to Yale in 1965 to teach, and especially after his MoMA
retrospective in 1971, Evans talked more about art and less about truth.
In this letter of 1960 he equates *truth* with *reality*; these both seem to
me to go with the *open window staring straight down a stack of decades*.
He thought, it seems to me, that somehow, through some gift of intu-
ition, he was able to frame truth with his camera.

In actuality, in his *mechanism* for finding truth, he resembled Al-
fred Stieglitz in much of his work—in *most* of his best-known work.
What Evans recognized, when he photographed with such intuitive
sureness, was not some unmediated self-interpreting truth but rather
his own construction of it. Evans had been an enthusiastic reader since
childhood, but he was self-directed, and he read most deeply in writ-
ers popular (or at least known) in his own time. As a result he had a
strong sense of *how things were*: he was unencumbered by history, the-
ory, or the disorienting perspectives of other times or places.

He learned from his friends, and his friends included a number of
the best his era had to offer, many of whom had intellects more force-
ful (if not more complex or agile) than his own. He was especially per-
ceptive; he saw and absorbed much, took it in, kept it ready for use.
When he saw the cross in St. Michael's Cemetery, the steel mills in the
distance, and the workers' houses just across the street, between the
cemetery and the mills, he recognized "truth." He had learned enough
photographic technique to know to use a long-focus lens to flatten per-
spective, so that the foreground cross and background steel mills

would look pressed close together, squeezing the workers' houses in between. He saw this photographable scene as truth—a *visible* truth related to an *understandable* truth derived from economics and history he may have heard talked about at, say, Ben Shahn's.

Picture after picture of his best-known work involves this kind of recognition, and explanatory glosses readily suggest themselves to tell how a colonnade is burdened with a ridiculously inappropriate Gothic-style tower (an attached sign says *wrecking company*), or how a windrow of dead cars contrasts with the distant rolling hills beyond. Wherever Evans may have thought *truth* came from, it had the same source for him it had for Stieglitz: it came from the artist's response to the scene. For Stieglitz, the response was overwhelmingly emotional, and often channeled into an idiom that looked modernist in form but still clung to late Romanticism. For Evans the response was circumspect and frequently literary, and it was articulated as *pure* modernism, in attitude as well as appearance.

The *truth* for Stieglitz was his emotional state, his response, how he felt. He had been taught to feel by German Romanticism, and he hated the nattering distractions of modern life. Characteristically the feeling is so strong, and so grandly stated, that his subjectivism hardly seems a limitation: it is the source of what his art is *about*, a self's response to the world.

For Evans the truth was *his take*, what he made of what he saw. His subjectivity often seems stretched, even denied: sometimes his perspective seems so large, so perceptive about how this culture works, that the viewer hardly notices the vision is subjective at all: it seems to be the simple truth. But, as in Stieglitz, the artist—the deeply read man of the early twentieth century, the friend of poets, the connoisseur of machine art, speed, change, dislocation, and the chaos they bring, the heir to Baudelaire's painter of modern life—the artist is there. The viewer of his work sees the world through *his* eyes, almost always.

But perhaps not always. For a long time I have felt that some few,

exceptional pictures have a different kind of connection to their maker. In the pictures I have described so far, the artist—Stieglitz or Evans—*uses* the world he sees, willfully shapes the material, enlists every detail to "express his theme" in order to present a view we recognize as "a work of art." Although Stieglitz presents one kind of truth and Evans a very different other kind, they both work in the same subjective manner: a thinking subject sees, and shapes, an object; the seen, shaped object is what we recognize as the "statement," the work of art. The artist exercises his mastery and control over the object in front of the camera in order to shape, to form the material so that it presents his vision, expresses his theme.

But in the instances that concern us now, the object or view chosen threatens to overwhelm the viewing subject, undo his mastery, thwart his control. The result is a kind of rude shock to the artist and leads to a different kind of picture. Let me try to explain by referring to the close portrait of Allie Mae Burroughs taken by Evans in the summer of 1936.

There are three (maybe four) 8x10 negatives, all made from the same close camera position. Evans seems to have persuaded the woman to stand against the clapboard wall in front of his camera, which would have been less than three feet away. At this range the depth of field—the range of clear focus—is extremely shallow, and asking the woman to lean against the wall would have made it easier to keep her eyes and face in clear focus. In addition to providing the visual interest of background, the wall may have been enlisted to provide the kind of steadying support that a headclamp added to portrait sessions in early studios.

Evans made several exposures, at least the three (or four) that survive, perhaps more that were not saved, maybe even never developed (his field notes from 1936 have not yet surfaced). A film holder must be inserted into the camera before each exposure, and the lens shutter (opened for viewing) and aperture (also opened widest for viewing, so

as to give the brightest possible image on the ground-glass screen) then adjusted: the shutter closed and cocked, the aperture stopped down to the proper setting. Next the dark slide covering the film in its holder is removed, and only then is the exposure made. Repeating this procedure three (or four) times, plus the initial framing and focusing, might have taken as little as two minutes, but not much less. So Evans held her there, in place, for at least that amount of time.

This holding may have been all the control he managed to assert over the material he chose for this picture. There are some formal elements worth noticing—the line of the edge of the shadowed clapboard behind, for example, which neatly hits the left ear, bisects the left eye, passes through the right eyebrow, and above the top of the right ear, making an arrangement more lively, less static than a strict level alignment of eyes, ears, and board edge—but particular details of the picture's *form* are not the picture's most important features.

More important than rigorously controlled form is the heightened sense of reality, the unavoidable factlike quality of the picture. Partly a result of the accurate verisimilitude characteristic of photography from its beginning, and partly as a result of Evans's exploitation of this quality in setting his apparatus so close to the person his picture examines, the picture is remarkable for its *facticity*, its arresting presence. It reaches back to photography's earliest days, when accurate verisimilitude was the only kind of truth that was sought.

Early pictures caught Evans's attention when he was first starting out as a photographer. Lincoln Kirstein reported that in 1931 Evans gave him a group of six photographs, small nonartistic studio portraits. According to Kirstein's recollection, Evans was interested in these pictures because they demonstrated "what photography could do." No record that I know of written by either Kirstein or Evans discusses what, specifically, it was that these particular photographs show; Evans, however, briefly but significantly refers to unsophisticated early photographs in his 1931 *Hound and Horn* essay:

> The real significance of photography was submerged soon after its discovery. The event was simply the linking of an already extant camera with development and fixation of image. Such a stroke of practical invention was an indirect hit which in application was destined to become tied up in the peculiar dishonesty of vision of its period.

The "real significance," it seems, is accurate verisimilitude, identity of aspect. The "peculiar dishonesty of vision" comes from the art photographer, "an unsuccessful painter with a bagful of mysterious tricks." In opposition to this "dishonesty" stands *honesty*—the truth (Evans, who knew his Joyce, will not use this "big" word in connection with his own work until he nears sixty) of accurate verisimilitude.

The illustrated two photographs Evans gave Kirstein in 1931 are unremarkable enough as images, but they do repay a more-than-cursory examination. The gestures of the two sitters, or standers, are almost mirror images of each other, and each grasps a finial of the sitting-chair between thumb and finger of opposite hands. Both stand stiffly, staring at something other than the lens of the camera.

Little of either man's character is made to show: the portraits could almost be two pictures of the same man at different times, just as the chair seems to be the same, seen from different angles (the pictures come from studios with different names but the same street address). Their proportions (arm length, head size) are slightly different, so they are likely two, but united in their youth, their desire to appear serious, their stiff, erect stance (aided by the neck brace, the base of which is visible near the feet in each picture). Both wear frock coats (perhaps carried to the studio to be put on not long before the session, as the creases in the sleeve and front of one suggest); the hair of both is smoothly slicked down for the picture.

The *truth* that these little *cartes-de-visite* show is not a revelation of individual character or "personality." Rather, the pictures tell of aspiration and pride of achievement. The two men are shown as they

would want to be seen, but the pictures show not just the attitudes they want to present but also the fact that *they want to*, have put forth effort to display those very attitudes. These pictures bristle with facts not because some "artist" has put them there but because the pictures record *all* the circumstances of their making. These little pictures disclose a truth larger than what their maker controlled or could have predicted. With these considerations in mind, formal control matters less than what might be called (reversing Evans's formulation) the *peculiar honesty* of the vision.

This understanding, I think, is what Evans took from these early pictures, and this understanding was part of his working self as he approached the Alabama woman, Allie Mae Burroughs. He understood photography's penchant for accurate verisimilitude—*that* he could attain by setting the camera up and training it on the woman. Rather than settling for this, Evans chose to set the camera close, so close he forces the woman to respond—to assume a character—and by doing so he sets the stage for a picture that will be about that response—hers, not his; about *that character*, whatever it may turn out to be. Accurate verisimilitude begins to take on an uncontrollable psychological aspect. Evans's picture invites a truth beyond his prediction or control, though—unlike the early workers—he was sufficiently aware of what was going on to be receptive, excited, tempted. *Sufficiently aware* hardly does justice to Evans's situation. The young man who had confided that the possibilities of photography so excited him he sometimes thought himself "completely crazy" stood, and must have known he stood, on a threshold—a threshold leading to a rich new vein of work that would be done in the subways of New York City, in Bridgeport, in Detroit, and in Chicago.

The strong response and arresting presence of the character, the woman presented—and not the "artist's" skill at composition and printing—account for the full power of this picture. The photographer has found an open, even light so that the face can be seen clearly, its

appearance uncompromised by the hard-edged shadows that direct sunlight would produce, but it is the face itself—the still-young skin stretched across bone and muscle, the tense expression lines just beginning to settle in as wrinkles, the severely dealt-with hair, above all the compressed mouth and the resolute answering stare—it is the face itself and not what the photographer has "arranged" or "lighted" or "interpreted" that makes this picture memorable, and important.

"She refuses to be an object at all," Lionel Trilling wrote in the *Kenyon Review* in 1942. "Everything about the picture proclaims her to be all subject." Her refusal to be an object upsets the arrangement of *seeing subject* and *looked-at object* that produces the *truth* in much of Evans and in the work of Stieglitz. This upsetting of that order is what, to my mind, sets a picture like this apart. The picture's exceptional, amazing feature is that, instead of a *subject* looking at and understanding an *object*, it presents to us one subject looking at a second subject, who for her part looks back. The picture presents not just a perception, the artist's "take," but an *encounter* between forces of comparable, if not equal, magnitude. The two subjects struggle for control of the picture—for authorship of its truth, and the force of this struggle carries photographic truth into new, uncharted terrain.

To anyone who has followed the argument thus far with any sympathy, this picture will suggest a state of affairs hardly less than extraordinary. A talented, sophisticated, accomplished photographer—a young master working at the height of his powers—is attracted to set up a picture-making occasion in which he knows he will not have the final say. His model's desire, say, to keep her lips compressed to hide her ruined teeth, will trump any preconceived notion he may have about *how she should look*. Any attempt to "enlist every detail in the expression of his theme" will be thwarted by the subject's—the *other* subject's—own independent will, unless he tries to pose her.

I don't think he did. What could he have asked of her? Not a turn or tilt of the head, still less a hand brought up to the chin or cheek, or

eyes directed wistfully to some enigmatic attraction offstage. None of this kind of intervention shows in this picture.

Could he have requested a pensive or a resolute expression? The several negatives suggest otherwise; they seem random flashes rather than several attempts to supply some sought-after look. At this close distance, and with this degree of visual clarity, the elements of facial expression suggestive of psychological presence arise from tiny physical details, such as squint lines around the eyes, small tense furrowings of the brow, and a hard-to-characterize (let alone summon from a nonprofessional) compression of the lips. Such subtleties of expression would be beyond the range of deliberate control of all but expert actors or models.

Evans was, I believe, tempted to try fate, to see what might happen in this chosen face at this close range when confronted with an instrument capable of such extreme detail. He was willing to work with whatever appeared. In this photographic gambit, Evans approached Conrad's description of man's life: "a rapid blinking stumble across a flick of sunshine." For Evans, *rapid* would present no problem; the young modernist half in love with speed and change, for whom the word *suddenly* had incantatory powers, would not take *rapid* as a limitation. *Sunshine* he had studied as closely as he had anything, watching and catching its many slants and brightnesses, and heeding the distinct, separate shades of meanings appropriate to each, and a *flick*, a *blink*, was, for him, enough. Stieglitz's sitters reported exposures of many seconds, even minutes; Evans's field notes and negative sleeves record sunlight exposures of 1 second, 1/2, 1/25, even 1/50. A flick was all he needed; longer may have been more than he could bear. And his *stumble* was like the elegant pratfalls of Buster Keaton, the great athlete-clown who took misstep and accident as occasion for physical gestures of great beauty.

In pictures like this, Evans was tempted to press close against randomness, to court failure, to bask in "the cruel radiance of what is." A

self-confident master of rhetorical statement, he chose to loosen his working method enough to admit a full measure of the chaos of human life on earth.

TO DISCUSS this kind of encounter as *truth*, I need a definition of *truth* that differs from those I have so far considered. *Truth* for the earliest workers, I suggested, was accurate verisimilitude, a detailed likeness of the scene viewed. Later, with artistic consciousness of self, the artist's experience of the scene, his emotional response, became the *truth* to be expressed and recorded; whether this new truth also involved detailed likeness was a matter of choice. Then, with the decline of Romantic sensibility—as a preference for misty mountain prospects and soft darkness gave way to a passion for speed, machines, the new, the bright, and the hard—*truth* came to be thought of as a *version* of the scene, the projection of the artist's own person: Joyce's Dublin, Atget's Paris, Evans's America.

Except for the earliest naive form, all these photographic *truths* depend on the understanding, control, and mastery of the perceiving subject—the photographer. Only the earliest workers were content with a truth in the form of *this is*. Later, more sophisticated truths lie along the lines of *I know this* or *I assert that this is true*.

This later model resembles the question-and-answer procedure of the scientific method. The investigator finds answers—useful answers, answers that technology can build upon, answers that lead to other questions—but answers to the questions *the investigator frames to be asked*. Like a blind man feeling his way along a passage, such an investigator will move ahead, even accomplish many useful tasks essential to him. But the manifold splendor of the space he passes through, as it might look in a flood of daylight—is it a subterranean corridor, a narrow chamber with a grand high ceiling, or a tight, deep crevice open to the heavens above?—will never be a part of his experience.

45

The inquiry, so to speak, proceeds with the attitude of a canny predator looking for opportunities, *for material that can be used.*

I want to suggest that this central idea—the notion of the mastering, arrogating subject—from which these varieties of photographic truth spring is not the only possible source of photographic truth. Further, this model—the one that relies on a *perceiving subject* and a *perceived object* to constitute a view of the world—may not be large or open enough to accommodate the full truth of a picture like Evans's portrait of Allie Mae.

> Man has already begun to overwhelm the entire earth and its atmosphere, to arrogate to himself in forms of energy the concealed powers of nature, and to submit future history to the planning and ordering of a world government. This same defiant man is utterly at a loss simply to say what *is*; to say *what* this *is*—that a thing *is.*

Martin Heidegger published this version of his persistent complaint in 1950. His indictment of Western thinking dwells on the active, aggressive quality of man's use of the world, which parallels his diminishing capacity for wonder at the simple fact of existence and his increasing impatience with, even complete ignorance of, the simplest, most basic question: why are there *things*, rather than *nothing*? In Heidegger's analysis, this question was more urgent, more directly felt and worried over by Greek thinkers 2,500 years earlier than in his own time. He turned to these early thinkers, and to their thinking about words like *truth,* to refresh a thinking—the twentieth-century thinking of the West—he considered "out of joint."

The kind of large, open *truth* I am trying to attach to photography reaches back toward this initial, primordial sense of wonder, of awe. In pictures like the portrait of Allie Mae Burroughs the photographer abandons, *momentarily* forgets his mastery, his focused pursuit, his directed inquiry—he loses all these skills (or, more accurately, he sets

46

their value at nothing) in the face of an overwhelming presence, a rav-
ishing mystery that disarms narrow canniness and—to those who have
the capacity to receive it and to recognize its value—delivers a great
gift, a gift of *sight*. In the face of a vision of wholeness, the early Greek
thinkers so important to Heidegger—Anaximander, Heraclitus, Par-
menides—pushed language beyond its known limits as they struggled
to put the vision into words; the kind of photographic artist I am trying
to describe, a master whose mastery is disarmed, struggles against self
and will, against professional standards and the limits of craft, to find
adequate visible form for the sight vouchsafed him.

"Not to be, then, is impossible: to be, incomprehensible," wrote
Coleridge. "If thou hast mastered this intuition of absolute existence,
thou wilt have learned likewise that it was this, and no other, which in
the earlier ages seized the nobler minds, the elect among men, with a
sort of sacred horror. This it was that first caused them to feel within
themselves a something ineffably greater than their own individual na-
ture."

ALAN TRACHTENBERG has shown how the photographs of the Civil
War were changed when they were given captions and arranged into
albums. Looked at one at a time, the pictures show many messy disor-
ganized details, and much that is unpleasant. In the albums, arrange-
ment and interpretive captions provide mythic structure, recasting the
carnage as a noble crusade.

By the 1930s, sophisticated artist-photographers had begun to do
this interpretive work for themselves, within the frames of single pho-
tographic compositions. As Coomaraswamy proposed in 1924, they
learned to *make* pictures, pictures that made use of everything the
camera showed; they learned to organize their material so that the
"theme to be expressed"—for Evans and his followers this meant an

understanding of the scene—enlisted every element as essential parts of its expression. The world became, instead of an overwhelming source of awe, a playground for the educated imagination.

A shrewd consistency of control, mastery, practiced dalliance with aspects of visible reality—these lead present-day photography to its truth. But another, broader truth—the open truth discernible in the surviving fragments of the earliest recorded thinkers—endures, buried in oblivion, and flashes out, from time to time, in genuine encounters. If, at the start of the twenty-first century, photography still has any unspent capital left, it may be that its greatest reserves will be found in this direction, along the course established by the medium's earliest workers.

Thinking and Feeling

Tragedy, *comedy, history, pastoral, pastoral-comical, historical-pastoral, tragical-historical, tragical-comical-historical-pastoral* . . . attempts to classify works of art are doomed to break down. Slight but significant variations each require separate subcategories, until at last there are nearly as many categories as there are works to be categorized. Although a late addition to the arts, photography is no exception: there are almost as many kinds of photographs as there are serious and competent photographers. Speaking broadly and loosely, some may said to be "thinking" photographers—photographers concerned with the identity of the things their photographs show, and what those things, in the particular combination a single photograph might show, might mean. Works by "thinking" photographers submit most readily to the kind of verbal description this essay attempts.

Other photographers are more concerned with feeling—that is to say, with presenting objects or situations, or perhaps formal or tonal arrangements, capable of affecting the viewer directly, without reference to the kind of knowledge that finds ready expression in words. Any work of art—a painting, a piece of music, a sculpture, a photograph, a tragic drama—*affects* a receptive audience, every critic since Aristotle would agree. *Affect*, the noun, used by present-day psychologists, means *emotion*. When a work of art affects us we commonly say that it *moves* us. *Move* is, of course, a spatial metaphor for an emotional experience; we say we are moved, as if from one place to another, when what we really mean is that our emotional state is changed, from one kind to another, for example from calm and merely attentive to ag-

itated, excited, concerned. *Pity* and *fear* are the names Aristotle gave to the complex of emotions prompted by a tragedy.

But what is the word *emotion* but a metaphor itself, a representation as physical motion of some inner change, a change not of place but of state? How can we name that change, except as metaphor? There is no word more basic, more concrete. We are left with *feeling*, which names physical, not metaphysical, experience. But we know what we know: there is something else, something further, a thing beyond what we know from the senses, a thing we feel in our hearts, in the skin of our faces heated from within, in our accelerated breathing, in our brimming eyes. And we know we are able to feel these things not only at the sight of a predator, or of a loved one in distress, but also in the presence of a work of art, a harmless fictive construction: at a play, in front of a picture, during a musical performance, even in solitude, silently interpreting the meanings, and perhaps the sounds, of words.

With this general distinction in mind, consider the photograph of Kilterman dolmen made by the American photographer Paul Caponigro in 1967, while he was on a Guggenheim Fellowship in Ireland. A few years afterward, in 1972, he recalled to students that he had originally wanted to travel and work in Egypt. Because of war in the region, however, he decided to go elsewhere, to Ireland. He was drawn to Egypt, he told the students, because of its ancient monuments, and Ireland offered another version of this attraction. The Irish countryside is littered with huge stones, stones put into place not as long ago as the Egyptian ones, but long enough ago that no clear account of their origin, purpose, or meaning has survived. They are even more enigmatic than the colossal stones of Egypt, which are shaped into figures and covered with markings, many of which were eventually deciphered. An aura of spiritual, magical significance clings to the ancient relics of both places. Both seem to have come into being not for practical reasons—they were not tools of warfare or commerce—but rather to an-

swer a spiritual need of the peoples who built them. A sensitive, sympathetic observer of either class of monument might feel that some mysterious power resides in them still.

A photographer of a certain bent of mind who stands in front of a Gothic cathedral, or even a nineteenth-century wooden American house, will be aware of not only how the subject *looks*—how its mass is shaped, how it sits on its site, how it takes the light—but also of numerous historical glosses the structure's forms may suggest. This figure is Saint so-and-so, and these are the Old Testament kings; this treatment of the figure resembles certain mosaics; the wooden tracery decorating the eaves of this house recalls stonework found in European buildings of different ambition and much earlier date. Even if the photographer thinks of himself as an artist and not an architectural historian, these glosses will present themselves as a part of his experience as he looks at his subject, and they will affect, in some way, the picture he makes. At the very least, he may find himself taking care to make sure that some feature he recognizes as significant will show clearly and not be lost in deep shadow or on a side of the subject facing away from the camera.

When standing in front of an object from prehistory, the photographer is on his own. Unlike the stone in Timothy O'Sullivan's picture of Inscription Rock, no inscribed text helps explain the subject's significance. No patterns or other formal devices refer to any familiar history of style. The massive thing sits there mute in the landscape, a huge weight arranged in remarkable defiance of gravity, partially raised so that its broadest surface is tilted forward to face the viewer. Who arranged it? How did they do it? Why did they do it? The picture Caponigro made of this stone offers no more answers to these questions than does the thing itself.

In this picture the stone, in the gentle light of what seems to be early morning or late afternoon, massively inhabits the center of the picture in the same way the idea of the whale occupies the center of

Ahab's mind. The central object of fascination crowds everything else to the margins without eliminating them altogether—they are necessary too, though of interest and use only insofar as they help support, or present, or somehow serve the obsession. The dark ground and lush foliage establish the topography within (and above) which the thing sits.

The earth physically supports the stone, in actuality taking its weight and holding it up: the picture shows us this fact. But the dark, grassy earth also provides, in the picture, a visual setting, a tonally contrasting ground; it supports the central form visually as the earth it represents physically supports the thing the form represents. The sky is made to cooperate as the top part of this graphic, visual setting for the central object. I say *made to cooperate* because when a darkish object is photographed outdoors in shade, the exposure needed to record the details visible in the dark ground cover will necessarily yield a negative with much greater densities in the sky portion of the image. In order for details in the sky to appear in the print as they look to the eye, the sky must be "burned in," or given a printing exposure longer than the exposure for the rest of the image. The sky in this picture is carefully printed in so that a cloud mass, an approaching front perhaps, appears more prominent on the picture's right side, adding an area of visual interest at the top of that side of the picture—in a spot prepared by the narrower, lower amount of grey stone on the same (the right) side of the picture. The shape and visual activity of the sky cooperate with the narrow band of dark earth that snakes above the stone's upper edge to complete the top part of the graphic, visual setting for the central object.

The whole of the picture conspires to make this stone present to the viewer's perception, and imagination, as an almost holy thing, a part of nature raised somehow above the realm of ordinary, everyday nature (where gravity and history apply) by the unknowable effort and attention bestowed on it by an ancient people, and by the more recent

effort spent on it by a mid-twentieth-century artist. But is his effort re-
ally any more understandable than the effort of the Celts? I can infer
how he framed the picture, exposed and printed the negative, but I can
scarcely explain what passed through him as he first saw and then pho-
tographed the stone, or even guess whether he chose the stone, or the
stone chose him, except to say that evidence of a conviction of the
deep significance of the dolmen resides in the quiet beauty of the pic-
ture he made. Every visual detail and every tonal relationship visible
in the picture is handled with a degree of care amounting to rever-
ence; it is possible to suppose the photographer was in communication
with the spiritual significance of the sacred stone no less than were the
ancient—what? priests?—who put it there.

It is no accident that Caponigro has often been drawn to photo-
graph things that stand apart from social history. The carcass of a goat,
half buried in sand; a fragment of an Egyptian statue—not a whole
statue photographed in its archaeological context but a tiny fragment,
smiling lips, photographed against textureless black; Stonehenge; ap-
ples in a wooden bowl; sunflowers—these are the things he has been
drawn to photograph, and the prints tell not of their subjects' places in
some tellable, explainable scheme of things, some standard history of
the civilized world, but of something else. Actually they do not *tell* at
all, insofar as we mean by *tell* to give an account in words. Their am-
bition is hardly verbal. They seek a direct connection, a connection
unmediated, or mediated by feeling rather than by verbal understand-
ing, to that faculty which has traditionally been located in *the human
heart*.

Caponigro trained as a classical pianist, and his pictures invite
comparison to musical art. This analogy suggests itself for two reasons.
First, because music is the art least dependent on what critical writers
have called *mimesis*—the representation of things familiar from every-
day life in a work of art. A painting depicting apples in a bowl or a rus-
tic dance involves mimesis, or imitation. A drip painting or a painting

consisting of a colored geometrical grid does not. Almost all music—with the exception of pieces like Erik Satie's score for the ballet *Parade*, which includes a siren and a clicking typewriter—does not.

Music's effect on the listener arises most directly from the formal qualities of the work: from the arrangement of sounds, from the paced progression of notes and chords. It depends much less on the "subject" or "program" of the piece, even in songs. The sense of the text of *Winterreise* is unsettling, even in flat English translation, but it is the sound of the sung words, and the delicate second voice of the piano, now introducing, now accompanying, now undercutting, contradicting, and reinterpreting—it is the *sound* that delivers the full emotional charge of the music.

In Caponigro's pictures the "subject matter"—the collection of physical objects photographed—is usually recognizable, often startlingly clear because of his masterly understanding of light and form and the photographic techniques needed to render them. But often it is the manner of rendering—the translation of a scene into a tonal palette—rather than any nameable or explainable feature of the subject that accounts for the sense of wonder the pictures embody. According to Aristotle, a work of poetic art contains narrative or plot (*mythos*), characters (*ethos*), their thought (*dianoia*) expressed in structured speech or diction (*lexis*), a setting or spectacle (*opsis*), and a musical component (*melos*). To adapt these critical terms to a poetic photograph, Caponigro's photograph can be said to concern itself almost exclusively with spectacle and melody. The viewer responds not so much to anything anyone might know or say about the thing shown—no story is implied, no people involved, only barely implied as the possible agents of the stone's elevation (and as inhabitants of the tiny houses far off, on the slopes of the hills on the other side of the valley), no rhetorical argument put forward that might be answered or criticized. Rather, the viewer responds to the presented thing itself, in

its setting—the *opsis*—and to the manner of its presentation, the linear, spatial, and particularly the tonal form of its showing—its *melos*.

Fable, character, thought, diction, spectacle, melody: these terms of Aristotelean analysis come to a reader in 2002 covered with the dust of centuries. They smell of musty books and the medieval schoolroom. They are such categories as might shape the dry thinking of Wallace Stevens's Professor Eucalyptus, seated in his book-lined study on an ordinary evening in New Haven. They remind us that Aristotle was a great, relentless explainer, a word-man who named and analyzed everything, even the feelings arising from tragedy and the most effective means of producing them. When words fail him (not often), he takes the trouble to point out that the thing he is defining is a thing for which there is no word.

But take one of these categories—*melos*, or melody, which for Aristotle meant, literally, music: words sung as song, and instrumental accompaniment of lyre or flute. Critics of English poetry have for a long time considered the musical component of poetic art to reside in the language itself, in the sound and rhythms of words written to be heard, if only in the mind's ear. Melody has been understood metaphorically as an attribute of verbal art by critics as least as far back as the time of Samuel Johnson; as a metaphorical term of description it applies to pictures equally well.

Consider this term *melos* not as an idea with a long history, but as living practice, the production of a working artist. Thought of, or thought, this way, *melody* appears as connected patterns of rhythm, the continuous flow of nuanced structure against which a flash of bright color, or the soprano's high figure, stands out, or as the context from which *meaning* leaps to the understanding as the figure in a woven carpet leaps to the eye.

This melody is produced by the arms and fingers of the pit musicians in Degas's great pictures of theatrical performance, the players

whose dark, ruddy faces turn away from the bright spectacle on the lighted stage down toward their instruments, the tools of their art. In Eakins, melody *resides* in his knitted harmonious design, the result of a studied perspective and a scaled palette, but it *appears* as the shadowed piano accompanist, whose figure and face with its enigmatic, abstracted expression are rendered in dull colors, smudgy quarter-tones eclipsed by the full, strongly lighted figure of the singer of the pathetic song, and again as the lone hand of the conductor shown in the lower left corner of *The Concert Singer*. Melody, played by flute and lyre players, supported the rhapsodes familiar to Aristotle. Whether played on instruments, or sung, or only voiced through the words, or put into the harmonious design of a picture, flowing structure can be thought of as melody. In a photograph by Paul Caponigro, melody is the purposeful, smooth visual structure—the arrangement of line and especially the deployment of tonalities: not the bold chiaroscuro of photojournalists but delicate arrangements of infinitely distinguishable values of grey, shaded notes of a tonal scale.

The best word to describe the connection between *melody* and those who make it is *participation*: those artists responsible for it can be said to participate in the melody. Their nerves, muscles, and fingers produce the sounds; the senses monitor the sound produced, but also hear and respond to them. Each musician is a part of the larger whole, the music, the melody each hears and feels as well as makes, the sound pattern made by each and felt by each: felt as physical vibration but also felt as emotion. The participation is visceral sensation as much as deliberate making. In one sense the separate finger movements producing the notes are no more individually willed, as discrete movements, than the automatic toe-tapping, at once guide and response to rhythm.

Participants in *melos*, melody, give themselves over to it. Musicians merge arms and fingers with the rhythm and notes of the music; arms, wrists, and hands of painters are in play as the pattern of the picture

emerges. The length of a line and the sureness of its course come di-rectly from the gestures that a painter's musculature and frame habit-ually make. Years of training and practice ensure that the musician's trill, the painter's mark, the dancer's leap will be part of the pattern, the pattern itself: effective as structure but also *characteristic*, as recogniz-able as handwriting.

The craft of photography is indirect and mechanical. There are several steps from *scene* to *print*, and each involves calculation and the adjustment of mechanical devices. With repeated practice, though, even this sequence of machine-aided operations takes on the charac-ter of the operator. The calculations for exposure, for example, are rel-atively simple, and experienced black-and-white photographers often work without measuring the light (as did all photographers before the invention of the photoelectric cell). Shading, or personalizing, the "correct" exposure becomes an automatic practice, almost a habit: in hard sunlight, give the scene a little extra exposure, to support shadow densities in the negative; on a soft day, use a thinner exposure and de-velop the negative a little longer to expand the tonal contrast in the re-sulting picture. Many photographers (Caponigro included) use film supplied in large sheets the size of the plates used by the earliest pho-tographers. With this material a photographer can develop each piece of film for a different time, altering the tonal scale from negative to negative, even when the negatives are of the same or similar scenes. Some photographers use a faint green light to watch the last moments of development, pulling the negative out of the bath not at some pre-determined time but when it looks right to them.

Printing offers even greater latitude. In the printing darkroom, a controllable light source is directed through the negative onto the piece of sensitized paper, which will become the print. Light can be withheld from some parts of the image and overapplied to other parts—the bright cloudy sky in the Caponigro picture, for example. The process of developing the exposed paper can also involve various

idiosyncratic controls, including the use of multiple developing baths and spot developers. Ansel Adams takes fifteen pages to discuss print processing in his instructional book *The Print*; the complexity of strategies and devices for control are limited only by the inventiveness and patience of the photographer. Stieglitz reported using up dozens of sheets of printing paper to arrive at one print that satisfied him.

Over time—over years—these mechanical operations, along with other such considerations as framing, preferred viewing distance, experience with (and thus increased knowledge of) subject matter, and favorite locations all become interwoven into a dancelike process, not as direct as action painting but just as responsive to the individual preferences and quirks of the controlling photographer. The process becomes, at least in part, reflexive rather than deliberate. When such a working process is mature, a picture produced by it is distinctive and specific, both in the sense that it looks like the work of *just that artist*, and also—in the case of a photographer who is very good—in the sense that the picture looks like a response to *just that particular scene*, and no other.

In discussing *melos*, Northrop Frye distinguishes between art that has melody because its aspect is pleasing in some general way, and art whose melodic component purposefully advances the argument of the work, even though it may do so in a manner that shocks and startles. The photographer and longtime teacher Tod Papageorge often made a similar distinction in classroom critiques when he would (somewhat archly) describe a student effort as "simply beautiful." This critical term served to point out the shortcomings of facile, overeager young photographers who had learned to make shimmering silvery prints of whatever they pointed their cameras at—prints that were tonally pleasing but uncritical in the sense that they took no close notice of the things in front of the lens. Like the pictorialists of the early twentieth century, these eager students sought to throw a veil of "beauty" over the visible world.

Tonality contributes heavily to the *melody* of Caponigro's work. His smooth greys please the eye, but in this picture they pay close attention to the picture's occasion, its subject matter and setting as well. These "beautiful" tonalities result from just the kind of lifelong participation in an integrated, reflexive work process I have described, but their deployment in this picture is not indiscriminate beautification, reflexive in the sense that it is a knee-jerk reaction. For all their lushness, the tonal values are ordered, disciplined into an effective organization contributing another, deeper dimension to my description of the picture's "structure."

The darkest tonalities congregate in the lower part of the picture, in areas representing the earth's surface. There, elements of moistly dark vegetation outdo each other in near blackness: low dark-grey weeds appear against the darker ground, separated from it by the even darker shadows the masses of weeds create. The concatenation of close near-black values suggests the suppressed tonal world of Ad Reinhardt's black canvases; only a few smaller stones (and these, darker than the central dolmen, may have been printed down somewhat) relieve the uniform just-visible darkness.

The other extreme of photography's tonal scale is explored in the sky, where wispy light greys fade into the near white representing the bright clear sky. A patch of darkening grey collects in the farthest reach of the upper right corner, but most of the sky area is light, luminous. Only the central massive stone, the dolmen, displays a large area rendered in middle greys, the tonalities from the center of photography's scale of usable values, the tonalities best suited for presenting teeming detail. With these middle greys, printed from a sharp-focus large negative, the viewer is in the world of Frederick Somer's Arizona landscapes, prints made up almost exclusively of middle greys, prints whose abundance of detail astounds, almost stupefies in its sheer quantity. The wealth of surface texture visible on the Caponigro's Irish rock fairly leaps to the eye, making its visual presence in the print—its exis-

tence—of an order of reality different from the compacted blacks of earth and the wispy, airy light tonalities of sky. Tonally as well as visually and spatially, the stone is suspended, a face tilted forward for the viewer's close examination, between the dark and the light, a thing inhabiting some middle ground between the sky above and the earth below, as we ourselves do. In this picture, stone, photographer, and viewer meet on equal ground. The stone is not an object of condescending understanding, a member of some lesser class of things to be *studied*, but a pure *presence*. In its deeply felt and carefully managed *melos*, the scene shown—the *opsis*—presents almost an *ethos*, a character, one as mysterious, demanding, and worthy of attention as any of us might be in the right drama.

I SAID EARLIER I had *two* reasons for suggesting an analogy between Caponigro's photographs and musical art. The second is historical, a thread running through twentieth-century art photography, a recurring tendency to think of photographs in terms appropriate to musical expression. Alfred Stieglitz, who took his titles seriously, called a suite of his pictures from 1923 *Songs of the Sky*; a single picture from 1922 was titled *Music*. Stieglitz talked of his pleasure at showing a picture to the composer Ernest Bloch, who described the orchestration he saw in the photograph: here is the brass, here the strings, etc. Stieglitz found that a musical analogy served to convey the direct emotional appeal his pictures characteristically make.

Among his generation of photographers Stieglitz was not unique in finding musical elements in his own work. Edward Weston confided in his daybook (that plainspoken American modernist avoided the word *journal*) this exultant appraisal of a recent picture: "Whenever I can feel a Bach fugue in my work I know I have arrived." The younger Ansel Adams trained seriously (seriously enough to consider a career) as a classical pianist, and his theory of tonality in black-and-white pho-

tography—the well-known and widely taught "zone system"—has a clear link to the organization of notes into a musical scale.*

The idea of music appealed to Stieglitz because strong feeling was at the heart of his art. He claimed "the quality of touch in its deepest living sense" as a part of his work, meaning that looking at his pictures was for the viewer a nearly *tactile* experience, a physical sensation, a feeling. Elaborating on the emotional content of his pictures, he called them *equivalents*: the emotion he felt as he made the pictures—his *felt* experience of life at that time, as a whole—was put in objectified form into the print. The print was the *equivalent* of his feelings; a sympathetic viewer, looking at the print in a receptive frame of mind, could have access to that strong feeling. He or she could see/hear/feel the brass, the strings, etc., just as the composer/photographer felt them as he stood before the scene in his exalted state, at his moment of vision.

A photographer forty years younger than Stieglitz, Minor White, was sufficiently interested in Stieglitz's theory of equivalence to undertake a writing project on the subject with Meyer Schapiro of Columbia University. This project was never published, perhaps never

*Adams's "zone system" is a system of tonal analysis. It proposes ten distinguishable shades of grey, or "tonalities," progressing at regular intervals from Zone o—opaque, detail-free black—to Zone IX—bleached out, detail-free white. The photographer is expected to interpret the scene he wants to photograph as composed of these tonalities: the sky might be Zone VII (light but textured grey), the dark grass Zone IV (a shade darker than middle grey), the sunlit rock face Zone VIII or even IX, and so on.

After this analysis, he determines (on the basis of his own tests made earlier, under controlled conditions) the combination of exposure and film-development time that will cause the range of brilliances in the scene to fit within the recording range of the film's emulsion. By making a negative that can be printed to reproduce the shades of grey he envisioned when viewing the scene (note-taking is encouraged), the photographer should be able to make a print maximally faithful to his experience of the scene, at least as far as tonality is concerned. Thus a sensory experience is quantified, as in musical notation.

completed (in 1970 Schapiro recalled suggesting that White consider applying Heinrich Wölfflin's principles to photography)*. But White taught for most of his life, and his interest in Stieglitz's ideas about emotional expression became a part of the mixture of sensitivity training, Zen, Roman Catholicism, mysticism, and photographic technique that made up not only his artistic practice but also his teaching, which influenced a long line of young photographers. When White taught at the Rochester Institute of Technology, one of his students was Paul Caponigro.

Caponigro himself has taught. In the early 1970s, when he was living in Connecticut, he regularly gave weeklong workshops for photography and design students at Yale University. Sometimes the students showed their own work to Caponigro; sometimes he organized field trips or other teaching exercises. In one of these, he invited students to expose pieces of printing paper for different amounts of time, using an enlarger with no negative in the carrier. After processing, the students had many sheets of paper, each sheet a uniform page of even grey, and each sheet a different tone. Then the sheets were cut into small squares, and the students played at juxtaposing different tonalities. The idea was to see the effect of tonal composition when the elements of line and subject matter were removed. It was an exercise of pure *melos*.

His reviews of student work during these years are memorable for a combination of intensity and silence. When presented with a stack of finished prints he would look at each one, slowly and deliberately, and then look through the stack again. Gradually he would separate

*Wölfflin, the Swiss-born art historian, proposed pairs of opposite terms for use in analyzing the formal structure of a picture. His *Principles of Art History*, first published in German in 1915 and widely translated, made these opposed terms (*linear* versus *painterly*, for example) part of the standard art historical vocabulary. Needless to say, Wölfflin's descriptions of visual appearance pay more attention to the history of style than to the expression of emotion.

out some to look at yet again, and then narrow the selection further. At the end of the mostly silent process, two or three would still be in his field of vision. He might settle on one, and finally speak: *It sings*, I remember hearing once. On another occasion he simply asked to buy the print.

Absence of talk did not mean nothing was happening in the room. On the contrary, the atmosphere was charged, and the attention Caponigro paid—the *looking*—was evident, pronounced, and remarkable. The small talk and jokey banter, the easy gesturing that had been going on a few minutes earlier, ceased abruptly once the looking started. He settled into a posture of serious looking, all talk stopped, and his eyes focused on the prints without wavering. Only the movements needed to put one print aside and take up another broke the stillness. At the end, when he finally spoke, the room relaxed again into talk.

In his teaching room as in the world of his pictures, talk has its uses, but words are not the way to the heart of the deepest mysteries. Explainable, nameable elements—this is an animal that has died, this great stone is not on but slightly above the earth—are important, necessary to set the stage. Ahab needed to talk to the crew, see that they were fed, tend to business, and temper the harpoons, but the whale, the stone, is central, and unexplainable: not accessible to reason and the tools of analysis.

It is no wonder Caponigro was attracted to stones that are prehistorical. The Romans had their historians, writers who left accounts of the times they lived in or knew about, including the very advance that pressed the Celts to the rocky, ragged edge of Europe. These Celts left no written accounts. Their thinking, their experience of the world, their connection to Nature and to their gods found lasting expression only in the mute, brooding presences that still sit heavily on the Irish earth. In contemplation of, perhaps communion with, these ancient, silent things, Paul Caponigro found perfect occasion for the exercise

of his artistic gifts and a temperament especially susceptible to the melodic component of his art.

In making this picture, his eyes, ears, nerves, and muscle were all involved, as well as the part of the brain responsible for connecting and coordinating them, involved and given over to the production of, to participation in, *melos*. Whether other parts of the brain—those involved in reflection, in analysis, in verbal thought—were also involved is not a question I can answer. I can only observe that little evidence of these activities found its way into the finished print. Participation in this *melos*, for many artists, is a thing apart from the analysis, the explaining, the masterful and relentless word-use of Aristotle. It is almost another mode of being, one allowing a direct connection between the emotional apparatus and the felt world.

At the risk of protesting too much, I want to underscore the seriousness, the *respectability* of the kind of *knowing silence* I am trying to describe, and to avoid anything like condescension in my attempt to give a just account, in words, of an experience that is wordless. It may help to call a final witness who is sympathetic but also articulate. Samuel Taylor Coleridge threw himself into and relied on language as much as any Englishman of his time; he wrote about the need to create new words when a thought or experience arose that could not be named, or when a single concept became so large, like a growing cell, that it must divide. A single prose work contributed six or more solid English words (such as *reliability*) used by him for the first time (according to the *Oxford English Dictionary*).

Yet Coleridge understood knowing silence. He recognized the "important fact that besides the language of words there is a language of spirits . . . and that the former is only a vehicle for the latter." What is the language of spirits? His explanation is not the stumbling attempt of a mystic hostile to and ill at home with verbal thought. He paints a beautiful word-picture to suggest just what this language of spirits is, and how it might be thought (by some at least), wordless as it is:

The first range of hills, that encircles the scanty vale of human life, is the horizon for the majority of its inhabitants. On *its* ridges the common sun is born and departs. From *them* the stars rise, and touching *them* they vanish. By the many, even this range, the natural limit and bulwark of the vale, is but imperfectly known. Its higher ascents are too often hidden by mists and clouds from uncultivated swamps, which few have courage or curiosity to penetrate. To the multitude below these vapors appear, now as the dark haunts of terrific agents, on which none may intrude with impunity; and now all *a-glow*, with colors not their own, they are gazed at, as at the splendid palaces of happiness and power. But in all ages there have been a few, who measuring and sounding the rivers of the vale at the feet of their furthest inaccessible falls have learnt, that the sources must be far higher and far inward; a few, who even in the level streams have detected elements, which neither the vale itself or the surrounding mountains contained or could supply. How and whence to these thoughts, these strong probabilities, the ascertaining vision, the intuitive knowledge, may finally supervene, can be learnt only by the fact. I might oppose to the question the words with which Plotinus supposes NATURE to answer a similar difficulty. 'Should anyone interrogate her, how she works, if graciously she vouchsafe to listen and speak, she will reply, it behoves thee not to disquiet me with interrogatories, but to understand in silence, even as I am silent, and work without words.'

Silence is not necessarily lack of understanding; an absence of words, even of the possibility of words, does not indicate that nothing is present. The works of some artists preclude speech, as the works of others encourage it. The range of photographs produced since 1839 suggests that the practice of photography offers an arena large enough to accommodate workers at both extremes of temperament, Aristotle at his lectern as well as the flute-girl in the pit, maybe even a few comfortably at ease in the presence of both.

THINK OF CAPONIGRO ENTRANCED, looking at the Irish stones, and then think of John Ruskin, writing about the stones of Venice, or Henry Adams sitting on the stone steps of Ara Coeli, where Gibbon sat, looking out over Rome. Ruskin and Adams felt as well as looked, but words were never more than a synapse pulse away. They explain, or at least they make connections, flashing out in all directions, bringing this fact and that tradition to bear so that, as we read them, we know the things they look at but much more as well, a whole geography of civilization, and the map is made of words.

The work of some photographers seems to invite the attention of such temperaments, and none more than the work of Walker Evans, whose pictures suggest literature as Caponigro's suggest music. Improbably, some of the same Yale students who were a part of Caponigro's silent, intense critiques in the early 1970s also took classes with Evans, who was on the Yale faculty until 1972. Fresh from experimenting with tonal composition and hearing that a picture could *sing*, a student might sit down to show a handful of prints to Evans. Looking quickly, Evans might take a picture as occasion for a rambling if fascinating digression on the arrangement of furniture in English country houses, or perhaps as opportunity to ask where such a bit of interesting, possibly collectible rubbish happened to be located, exactly. The student was met with a barrage of conversation: worldly, witty, wide-ranging, broadly educative and amusing, but connecting only sporadically with the pictures at hand, or with photography at all for that matter. One got the sense that photography and ideas were connected, somehow, perhaps if only in that the ability to photograph was one way (of many) to participate in the life of the mind. Feeling, in this world, was oblique, never directly stated or even acknowledged, a mysterious source of energy that somehow fueled the liveliness the mind craves without ever becoming the topic of discussion.

Evans's brave (in the older sense of the word) verbal presence in

the classroom is as related to his artistic gesture as a photographer as
the serious silence of Caponigro's critique is connected to his quiet,
strongly felt pictures. It is temptingly inviting to talk about some of
Evans's pictures as if they were texts, pages of literary (not journalistic)
writing displayed in picture form. To begin with, many of his pic-
tures—*Joe's Auto Graveyard*, for example—show scenes in which per-
spective is compressed, flattened to minimize the illusion of deep
space.

A few of his best-known pictures are quite literally flat, photographs
of subject matter with very little actual depth (the tenant farmer's
kitchen wall, from 1936) or none at all. The best-known picture of two-
dimensional subject matter is his photograph of the penny-picture dis-
play, the well-known *Studio* picture. Oddly, this picture seems to show
a window display—the outlined letters spelling out STUDIO seem to be
applied to a glass window just in front of the display. I say oddly be-
cause no trace of the photographer and his camera can be seen in this
glass. Eugène Atget sometimes appears reflected in the rippled glass
of the shopfronts he photographed, a reminder of the deep, three-
dimensional space the flat façades actually inhabit. Other photogra-
phers (notably Robert Frank and Lee Friedlander) make their own
reflected images a major component of the picture, emphasizing not
only the dimension of depth in the scene but also the subjective nature
of the investigation being undertaken in the photograph of it. But in
this picture the photographer has vanished, along with any indication
of deep space. The picture is as flat and as impersonal as the page of
an encyclopedia.

I turned to the Greek term *melos* to help highlight a salient feature
of the Caponigro picture just discussed. If there is a Greek term that
might help lead us toward the heart of this picture by Evans, it is *logos*,
often translated as *word*. If Caponigro's picture strains to turn a per-
sonal near-mystical experience into concrete expression, finding
melodic pictorial form while at the same time preserving as much as

possible of the unexplained (and inexplicable) mystery of the en-counter that is the picture's motive, then this picture by Evans can be said to aim at turning life not just into art but into text. His picture is a view of a piece of the world, but at the heart of his looking is an am-bition, perhaps an irresistible urge, to turn his view into a page of lit-erature.

In 1931 Evans wrote that the published pictures of August Sander suggested an intriguing possibility: the "editing of society, an almost clinical process." Portrait photographs frequently seek to present the *character*, or personal attributes of the sitter, but pictures of individuals also concern themselves with the sitter's station or role in society. This second ambition presupposes an idea of society as some kind of struc-tured whole, and such a notion was fundamental to Sander's accom-plishment.

Evans by contrast was something of an anarchist, and he could approach the notion of *social structure* only indirectly, ironically. His subway pictures reveal an interest in "the editing of society," as do the pictures made on the streets of Detroit and published in *Fortune* mag-azine as a portfolio of anonymous portraits titled "Labor Anonymous." His notes for this project include a list of possible picture captions cribbed from the help-wanted section of a contemporaneous Detroit newspaper. Setting up a camera in a downtown street and snapping a selection of passersby contrasts as nicely as any imaginable strategy could to Sander's reliance on a theoretical structure suggested by Os-wald Spengler, and the careful pictorial technique he used to find vi-sual form for his notions. The impatience, the jittery restlessness, the tolerance for (if not love of) the contingent nature of his own anti-pictorial pictures underscore Evans's grounding in—what? spleen? dis-content? chaos? feeling?

Whatever Evans's tolerance for notions about a structured society may have been, he *was* willing to try to take on a whole, as opposed to

one component, in a single picture. The portrait of Allie Mae Bur-
roughs explores the latter subject, the mystery of individual human
presence, about as provocatively as any other photograph made in the
twentieth century. *Penny Picture Display* explores the possibilities
available when contemplating the former kind of subject—the whole,
the collect, a crowd, a representative sample such as might profitably
result from "clinical editing."

The flatness of this picture is central to its ambition. What the
viewer sees is not a crowd filling a street, in perspective from near to
far and contained within some architectural space, but a crowd ar-
rayed in a flat plane, in no perspective or sequence but in a simulta-
neous *now*, each person present in his own little space, all at the same
time—no main and minor characters, no foreground and background,
but all equally present at the same time, with the same emphasis. Each
receives the same scrutiny, and all are present at once, as individuals
and also as a whole. The picture offers many charming vignettes, small
performances by character actors to be appreciated with the aid of a
magnifying glass. Each has his or her own social and psychological
presence. But what do they add up to?

The flatness suggests that the picture is a page of text, to be read
and understood: here is a sample of society in 1936, drawn up and dis-
played for your contemplation. Here you may read the truth of our
times in a cross section of our society. If other photographers (notably
Ken Josephson and, more recently, Abelardo Morrell) have pho-
tographed actual texts—books—with the aim of presenting them as
sensuous objects, Evans here photographs a "slice of life"—a collec-
tion of random smiling, suffering humanity, each working to put on
the best face for the camera, a sprawling sensuous (and sensate) mass
of flesh and blood, and presents them as a flat page of text, an analysis
to be read, the individual tiny portraits each distanced, by their small
size and by the competition of the many neighbors, from our human

contact and empathy. Here we see the "physiognomy of a nation" set before us (as the afterword of the book in which this picture appears as the second full-page plate explains).

And what do we read in this picture? What structure results from this "editing"? If he or she fights against the individual portraits' small size, against the picture's tendency to turn them into a texture rather than a collection of single portraits, the attentive viewer can find telling details. Some subjects are given the luxury of a second view—babies, for example, are often taken twice. Why? Babies, not yet conscious subjects, squirm. A careful, thrifty professional would reasonably risk the small expense of a second try rather than risk producing a blurred (in these pre-electronic flash days), and unsellable, picture. After all, thrift is important: as we can see, the photographer has worked each single sheet of film to produce fifteen portraits. He is able to accomplish this feat because he has added two sets of sliding baffles—one set vertical, the other horizontal—to his camera's back. By adjusting the baffles after each exposure, he is able to uncover a small portion of unexposed film while shielding the rest of the sheet from light entering through the camera's lens. This small investment has allowed him to keep the cost of the second (of first, for that matter) exposure at a minimum, a strategy the picture's title underscores.

Further, the viewer can see that the photographer is characterized by pride in addition to thrift. Here and there he has cut out a piece of a contact print and pasted it over a portion of the original whole print. The addition is meant to improve the display, showing the photographer at his best, perhaps by substituting corrected prints to mask inconsistent exposures, or by hiding flaws such as the all-white squares, spoiled pictures resulting from attempts when the shutter stuck open, or when the photographer forgot to stop his lens down to the taking aperture after focusing with the lens at full aperture, or when he neglected to readjust the sliding baffles to uncover a fresh square of film before the next exposure.

Pride, thrift (or greed): what other sins does this document reveal? The animated expressions of the women might suggest that the photographer was male, and a flirt (lust?). If tidiness isn't one of the traditional deadly sins, it may well be a sin in the anarchic ethics of a man who included on a typed list titled "Contempt for:" (along with "hobbies and hobbyists" and "limited editions") this entry: "safe experimentation in living or in expression." Of this sin this display is also guilty. Each contact print-collage contains 15 portraits, and the display presents 15 separate contact prints, a face of rock-solid neatness, a finished system. The 225 portraits become a texture, a tidy sample with the illusion of authority, an "editing" of society. But what does this "editing" really show? The expressed verbal component, the internal caption, gives the answer: STUDIO. The analysis presented is an analysis of the photographer's working method, a catalog of his sins.

So many tiny figure-ground units coming together as a shimmering grey quiltlike grid give pleasure to the eye, but how much more pleasure—and stimulation—is given to the *thinking brain* by this outrageous intellectual gesture, which is at once quotation, allusion, and rejoinder. In taking (with his camera) this ready-made collage, Evans annexes the work of another in the same way Henry Adams referred to the thought and work of Gibbon by sitting in his spot on the steps of Ara Coeli to contemplate Rome. Or—a closer parallel—as Marcel Duchamp annexed the work of Leonardo by importing the Mona Lisa into his picture and adding the moustache to make it his own. So Evans takes the found collection of faces and adds the caption STUDIO to make it his own.

What has he taken over? The faces of 200 or so (225 less the duplicates) human individuals, each a resident in the society of that place and a living character in his or her own right, each of whom came to the studio after planning and preparation, or on a whim of the moment, for his or her own reasons, to submit to the photographer's cajoling while they worked in his three-dimensional studio to collaborate

on a picture that might please, and sell. All this human and spatial complexity is drawn up and compressed, reduced to the flat pagelike plane of Evans's photographic film, turned into a single picture; all the hours of preparation and work are compressed into the fraction of a second Evans needed to record the image on the light-sensitive surface of his film.

As a part of its complex gambit, this picture casts a glance in the direction of the work of another photographer, August Sander. "The physiognomy of a nation," Evans's version of *The Face of the Time*, takes him a second or so to compile; August Sander spent a dozen years or more compiling and selecting the sixty portraits published in *Antlitz der Zeit*, the 1929 publication Evans noted in 1931 as an "editing of society, an almost clinical process." In Evans's editing there is no division into archetypal categories, no progression from earthbound men to abstracted intellectuals, no "last" men—just *men*, and women, and children, taken as they came in off the street, their order of coming recorded in the divided plates but revised somewhat by a little sprucing up on the photographer's part. In this social structure, the only architect is the photographer (or photographers, Evans and his anonymous unwitting collaborator). The analyst of this society is the artist. What higher authority could a man who scribbled a note to himself reading, "all education bad, especially higher education" be expected to trust?

Penny Picture Studio shows the limits rather than the accomplishment of photographic analysis. At first glance the picture suggests a wide view, an examination of society, but the structure of the picture, when looked at closely and thought about, collapses back onto the strategy of its own making, as if to conclude (circumspectly): The circumstances of its making are all we know for sure, or (more sharply): Don't be a fool, this is all we can trust. The picture is indeed a text, more than the (potentially) empathic examination of 225 views of a smaller number of human subjects—it is a wry if not a dark text, a text

contemplating the hard limits of art even as it purports to show the expansiveness, as some have put it, of photographic vision. It is a text whose toughness and skepticism refuse to participate in facile optimism or sentimental "humanity." It is a text from a photographer who thought the exhibition title "The Family of Man" was without meaning. It is also a text that can be read and understood only with reference to verbal thought, a work as close to visual poetry as any other picture I know.

It is important to note that this picture's failure—or refusal—to deliver the "analysis" it seems to promise is not lightly taken or presented in a flip, offhand way. The picture does not present, gleefully, the impossibility of larger meaning as a foregone conclusion; it does not revel in demonstrating the irrelevance of the portrait form. In this picture we are still a long way from the huge, brightly painted grids of photobooth pictures supplied by Pop artists in the 1960s, and engaged by a very different kind of mind. If Andy Warhol's gridded pictures, multiple views of the same mugging celebrity face, suggest that "serious" content no longer exists (or at least is no longer available to big-time high-profile art), and that a portrait doesn't really tell the viewer anything, his pictures take these notions as prior assumptions, as the premise of the work. The pictures are riffs on "modern" ideas his hip audience can safely be assumed to share, a gaudy celebration of the loss the pictures demonstrate.

Penny Picture Studio may approach conclusions of comparable nihilism, but the picture does not jump right to them. Its careful, measured examination of the subject matter clings much closer to the texture of actual fact. The tiny individual *Studio* faces, examined one at a time, do promise some kind of earnest revelation. And Sander is a real point of reference—the 1931 essay calls his work "a case of the camera looking in the right direction among people" and "a cultural necessity." This is not arbitrarily chosen, throwaway subject matter but rather "serious" subject matter, a piece of reality, the kind of thing that

might be seen through "an open window staring straight down a stack of decades." It is material which might have been dealt with differently. But—finally, through at least two attempts with separate framings and any number of subsequent croppings involving trimming negatives as well as prints—the photographer was drawn to *just* the viewing distance he chose, to present *just* that balance among the tiny faces, the neat *only apparent* completeness of the whole, and the silvery STUDIO gloss. The picture's distanced contemplation has become, inevitably, in spite of the careful recording involved, perhaps even in spite of the artist's initial intention, a *re*thinking, a critique of his anonymous collaborator's naive efforts as well as of the studied progress of August Sander. As we look at and think about the various kinds of information and references that make up the picture's beauty (it is after all a work of art), we work out their relationships only gradually, over the time we spend in contemplation. It is as if we follow the artist *as he is coming to a conclusion*; we take part in the critique along with him; we share in his thinking.

Oddly enough, this cerebral, verbal Evans—and there is no doubt his pictures invite such verbal analysis, summon as they do some Aristotle or at least Professor Eucalyptus to explain, to tell us what they *mean*, what their significance is—this Evans talked very little about any specific meaning his pictures might have. Again and again in informal conversation, as well as in lectures to students—rambling monologues, really, impromptu discourses set off by some student's question—he says he felt "something" was working through him. He remembered working surely, finding subjects and giving each the incisive inevitable form we now value in his head-on views of rural churches, his long views of industrial landscapes, his details of vernacular architecture and of junk, and his still, silent, evocative interiors. But he rarely said *why* he treated a certain subject a certain way. In response to a student's question about why he framed a dry cleaner's sign off-center, he paused and then answered with an artfully suppressed

chuckle, *Why, you know the answer to that yourself!* The audience laughed, and he went on to the next question. As for the "meaning" of his work, he wanted it clearly understood that his pictures were *art*, the work of an *artist*. Beyond that his interest trailed off, and his impatience rose. One of his many undated manuscript epigrams reads (I paraphrase from memory at a distance of twenty-five years), *Anyone who looks at Botticelli to learn about customs and costume of the fifteenth century is a pedant and a fool.*

Further, Evans reminisced that as a young man he had been a poor student because he was unable to concentrate on his studies. Sex, he said, was all he could think about at Williams and at Andover before. In a list dated the day after Christmas, 1937—a year after *Penny Picture Studio* was made—he typed out a list of people, types, ideas, objects, and practices under the heading *contempt for*: On the same day James Agee wrote out a longer list under the heading *Contempt or hatred for*. Another list in Agee's hand but found among Evans's papers and labeled in Evans's hand, dated the same day, is much shorter. It is titled *Like*, and the first two entries are *fucking* and *drinking*. If a clearer expression of Dionysian (as opposed to Apollonian) motives can be closely linked to a major photographic artist, I don't know of it. As Lincoln Kirstein wrote of Evans in his journal of 1931, "His actions are governed by springs pretty far below the surface."

Evans's pictures invite, yield to, almost demand a kind of discussion Henry Adams would have felt at home with. Yet the artist's recollections, as well as convictions to be found in notes and letters written at the time he was making these masterfully analytical pictures, show us a chaotic, contrarian temperament of another kind. We do not have to search Evans's papers to find evidence of this conflict—it is prominent in the work itself, in single pictures such as *Penny Picture Display* and especially in the sequence of pictures of his first (and most important) solo book, *American Photographs*. This book, published to accompany the 1938 Museum of Modern Art exhibition with the same

title, is not an exhibition catalog. The collection of pictures exhibited on the museum walls overlaps the set published in the book, but the book stands as an independent effort, an attempt to realize a book-length work in pictures only, without text other than the picture's captions, which were grouped together at the end of each picture section. The afterword by Lincoln Kirstein is not a text to accompany the pictures but an appreciation or understanding of the book itself, which is nothing less than an extended meditation or rhapsody or even epic poem, a national epic in pictures rather than in verse.

Each picture appears opposite a blank page; the reader encounters these pictures one at a time, in sequence, separated by the interval of time it takes to turn a page. Each picture is seen while the image of the last is just fading from sight but still fresh. The reader's "take" on each picture sets him up for the next; his gradually forming understanding of the thrust of the whole sequence comes into play as well. As the reader makes his way through the progression of visual experiences Evans has set for him, he comes to realize that the author's strategy is not to gratify obvious expectations. Rather, the photographer/author consistently provides surprises, violent shifts of context, and ironic reversals. Clearly his intention is not to give a straightforward account of the subject but to confound, confuse, and undercut any possibility of such an account. He seems as dead set on subverting settled meaning as Socrates.

Any close reader's experience of this book will supply his own unsettling version of its "content"; consistent with this book's anarchic character, each reader's version will be different, and all but the most superficial and obtuse incapable of resolution into a simple, neat summary. A small sample may illustrate something of how the sequence proceeds.

"Part One," which has no further title, presents fifty pictures, each reproduced full page on the right facing a left-hand page blank except for a sequential number. The picture opposite number 23 shows the in-

terior of a shacklike home, a tag of worn cloth-patterned linoleum on the worn floorboards, commercial advertisements on the wall, a broom standing bristle-end up against the wall and balancing, in visual weight, a slightly right-of-center bentwood rocking chair—a chair conspicuous, in this straitened setting, for its superfluous function (rocking in addition to simple support) and construction (the many shaped twigs of its elaborate frame). Both of the two previous pictures (numbers 21 and 22) depict rough wooden cabins, so the reader—*this* reader, at any rate—is likely thinking about rural poverty, perhaps about the response of the poor to the conditions of such poverty: the rocker is an unnecessarily elaborate, therefore *artful*, response to the need to sit, and the family shown outside a similarly rough cabin in number 22 is singing *hymns*, the atypically expansive caption given at the end of the section troubles to tell us. Even the two commercial signs on the wall (in number 23) can be understood to have been employed (by the tenants) as decoration: they are bright (if ironic for most viewers) illustrations of Santa Claus and two well-groomed capped-and-gowned graduates, positioned so they seem to be toasting each other with diplomas and Coca-Cola.

With all this aboard the reader turns the page and finds number 24, again showing a ramshackle wooden structure displaying commercial advertising—only this view shows an outside, with the view of half the street-level façade blocked by the side of half an automobile. The car's occupant is white while those who sit on a bench in front of the ramshackle façade are black. We are in Vicksburg, Mississippi, the laconic caption offers.

In number 25 the car is center stage, and the rectangular (more or less; time and its own weight have shifted it a little) wooden façade behind is covered not with ads but with auto parts—wheels, tires, fenders, and hubcaps. A lone female figure stands outside like a classical statue, torso frontal in *contrapposto*, head turned in sharp profile. We see all the way through the building to the bare trees on the other side.

The pediment sign names the parts store after an Indian nation: CHEROKEE PARTS STORE/GARAGE WORK. A summary of our progress so far suggests that the handmade rocker, a sort of aesthetic gem in the rough, has yielded to the auto, neatly framed against a simple wooden structure whose façade the auto has dominated, nearly obliterated with its detritus. Something about race and class seems to be in the mixture as well. This is not a photo essay designed for the pages of *Life* magazine.

Number 26 shows *many* cars, parked diagonally on the main street of a Southern town; the façades are seen from an angle, but the diagonally parked cars are perpendicular to the camera's chosen position, presenting themselves almost in profile. The advertising signs on the foreshortened buildings are all jumbled together and far from the camera, hard to appreciate singly (like Santa toasting the graduates) or even read. Number 27, *Main Street, Saratoga Springs, New York, 1931*, a view from on high—the perspective of the mountain view, the epiphany—brings this swelling movement to a climax: rows of nearly identical black autos fill the liquid main street and push the nineteenth-century façades aside, where they form a dense anthology of antiquated building styles piled in a jumble on each of the picture's lateral edges. Flailing elms, a piece of an American flag, gaslamps cast from iron in the shape of plants, and the exploding white of a misty sky also participate in the ecstatic dance this picture shows. By this point decoration vernacular, industrial, and architectural, along with a curious notion of progress, are in play, plus themes already identified, plus others appearing for different readers, and on successive viewings. I have studied and written about this picture since 1975; during this writing (October 2001—a time of many flags) I noticed the small piece of American flag on the picture's left for the first time.

Number 28 shows a similar view down a main street, but from low down, from eye level. A marble figure of heroism—a soldier of the Great War, also in *contrapposto*—dominates and surveys the scene, an-

other jumble of foreshortened main street façades, individual signs and decoration indistinguishable except for the words STORE and BEER. Instead of buckeye illustrations we see wreaths and stars, more American flags and direction signs. Number 29 enlarges the military gesture to near-comical scale with the grandiose gesture of a generic Van Dyked cavalry hero—he could be Jeb Stuart or George Custer—and number 30 abrubtly descends from the mock heroic to the low mimetic mode with the close portrait of a nongeneric, very individual, not to mention lumpish, Havana policeman. Number 31 continues the descent by showing three boys, unheroic sons of the American Legion (woman in the background, walking along as if to attend to necessary daily business in ignorance of boys in uniform and other male patriotic nonsense), but number 32 pulls us back up onto the star-spangled pillar of number 28, this time giving us the *face* (and withering hostile stare) of the dominating figure of military authority. A very different face stares out from number 33, standing at attention with arms shouldered: Are we actually supposed to laugh at the sight of a dark-skinned face made darker by the coal dust of his occupation, and at the joke of a fierce Legionnaire suddenly replaced, at the turn of a page, by a little black man with a shovel on his shoulder instead of a gun? Are we laughing at the little black figure, or with relief at being rid of a truly threatening presence? Or for both reasons?

Next comes number 34, showing the same white-bearded black face with gun, not shovel: not in any position of threatening authority but in the very different context of a poster for a minstrel show. Cartoon blacks engage in tomcatting, watermelon stealing, fighting with razors, chicken stealing—all the stereotypical behaviors. If we laughed at the Cuban dockworker, do we laugh at this as well, and at what aspects of it? Next (number 35) shows *white* boys with watermelons, and the decorated wooden façades are back, seen head on. Are we laughing now, or are we back to admiration of vernacular art, if in fact the vernacular art was ever admirable in the first place, closely linked as it

now seems to provincial narrowness—unless we can manage to think of it as expression grounded in precommercial purity?

"Part One" lurches ahead, gathering more freight at each stop, to number 50, showing along the way a view of a Negro quarter; run-down neoclassical façades with hand-lettered signs tacked onto the well-proportioned pillars; more hard stares from small-town onlookers, these nonmilitary; a domestic corner shrine featuring a cactus, the capital of a classical pilaster, the wedding portrait of a Portuguese couple, and an American flag; a couple of buddies, arm in arm, against a dark background, facing the camera; a romantic male-female couple on an outing, arm in arm, against a bright background, backs to the camera; a minstrel poster couple, dancing hand in hand; a couple of beds; a sleeping down-and-out figure on the pilaster-framed stoop of a New York City commercial building; and a fallen tree in front of the octostyle colonnade of a Louisiana plantation house. No single category of subject matter is pursued discursively, from image to image. The reader is not led through a narrative or an explanation, step-by-step in a picture-by-picture exposition. The captions do not explain the pictures' connections to one another, or, except in a few instances, explain anything about the pictures they describe. They only occasionally inject hints such as "Southern," or "posed," or "refugee" into the flux of ideas the pictures present. Any sustained line of analysis, any prolonged explanation the reader comes up with will be subverted, will turn back on itself as the things shown, or the context in which they appear, change. The minutely specific, the allegorical, the fictional, the factual, the touching, the banal, and the ridiculous compete for the attention of the reader, who can never be sure for long where the artist's intention ends and his own interpretation begins.

This sequence of pictures is not about "America in trouble (the Depression)." It is not about "the vitality of native vernacular culture." It is not about "the crassness of commercial culture." It is not about "the indomitable human spirit." It is about all of these, but all of these

as they exist in the book's present day, inextricably linked, mutually interdependent, all tied together. And it is about more—about elements of this mixture brought by each reader, at each reading. The book's structure not only allows for these contributions, it counts on them. Joseph Addison wrote that "a man of a polite [i.e., cultivated, developed] imagination . . . can converse with a picture." Back-and-forth conversation is exactly the kind of engagement these pictures invite. The reader, with his responses and prejudices, becomes part of the America the book is "about." To use Evans's own words (not written until 1960), it is about "actuality in depth."

But this book is not about "actuality" in the way that a history or a sociological treatise is about *what is*. How can a book whose structure encourages the reader to rethink, or unthink, what he or she thought just a few pictures ago, a book whose thinking continually turns back on itself, be about *anything*? If the sequence of pictures leads to no resolved conclusion, if it adds up to reversals and undercutting, what are we left with?

We are left with the experience of the pictures, each time we look at them, and with *the lively activity of mind* that accompanies our contemplation of these scenes from everyday (1930s American) life. We are left with a work that "stimulates the quickening of mental faculties," a thing that "gives the imagination scope for unstudied and final play." The quoted words are from a translation of Immanuel Kant's *Critique of Aesthetic Judgment* and relate to his systematic discussion of the beautiful and of the nature of *fine art*. What we are left with, by these pictures that turn back on themselves and tease (while stimulating) our minds, is what Kant calls a work of fine art, a presentation of *aesthetic ideas*.

According to Kant, beauty is primarily formal and cannot *not* be felt. It engages our imagination in such a way that is self-sustaining, that causes us to linger. Formal beauty attracts and holds us, and while it holds, it stimulates in the way a feeling stimulates. This *formal*

beauty can ally itself with *ideas*, with concepts similar to those we employ in reasoned thinking. Kant calls this combination an *aesthetic idea*, an amalgam that differs both from an intellectual idea and from pure beauty. Aesthetic ideas differ from the purely beautiful because they involve thoughts, or concepts, and from intellectual ideas because the thoughts involved are not developed according to reason or logic. A further difference is that pure beauty appeals only to the imagination while intellectual thought appeals to the understanding; aesthetic ideas engage both, and stimulate both. When both these faculties are engaged, the result is a "net gain" to the entire faculty of representation — to the "unstudied and final play" such ideas stimulate. *Final*, as used here, means that *play* is the end, or "purpose," of the stimulation. Unlike intellectual ideas, aesthetic ideas are incapable of resolution or conclusion:

> [B]y an aesthetic idea I mean that representation of the imagination which induces much thought, yet without the possibility of any definite thought whatever, i.e. *concept*, being adequate to it, and which language, consequently, can never quite get on level terms with or render completely intelligible. . . . [Such ideas present] a wealth of thought as would never admit of comprehension in a definite concept. (Kant, *Critique of Aesthetic Judgment* [49])

Comprehension is here used in its most concrete sense, meaning a *taking together*. What is being said is that a definite concept cannot, is unable to, take together — contain, or hold — the *volume*, or amount, of thought "set into motion" by an aesthetic idea. Just as a fire- or cloud-watcher finds a rapidly shifting parade of related images in the amorphous matter he looks at, the mind confronted with an aesthetic idea is stimulated to "an unbounded expansion" of the concept presented, its imagination moved to "spread its flight over a whole host of kindred representations." But for Evans, we must always remember, this "final play," this "unbounded expansion," this *wealth of thought* took place

not while watching the changing forms of fire or cloud. In 1936 it took place as he stood at that open window staring straight down a stack of decades—as he looked at the hard factual texture of his time.

Evans took no interest in Kant, but Kant took a considerable, detailed interest in the production of fine art and in the faculty responsible for producing it, which he called *genius*. His analysis of that faculty fed directly into, even directly influenced, the practice of art-making of nineteenth-century geniuses, including a couple who were Evans's acknowledged models. And, whether he knew it or not, Evans's artistic practice stands in direct descent from the model described by Kant. Genius produces according to principles it cannot communicate, does not itself understand. "[W]here an author owes a product to his genius, he does not himself know how the *ideas* for it have entered his head, nor has he it in his power to invent the like at pleasure, or methodically, and communicate the same to others in such precepts as would put them in a position to produce similar products" (46). Kant, of course, could not have been writing about *any* photographer, but if I were to encounter these isolated words, without knowing their author or date, and be asked to whom they might apply, I would confidently guess Evans.

Writing at the beginning of aesthetics, Kant stresses that beauty appeals to a faculty apart from the understanding: he is never more emphatic than when he maintains that the response to beauty is a feeling, not a thought. But he is equally clear in explaining how the sense of the beautiful can attach conceptual thought—how ideas of things can come into play as part of an aesthetic response—in a process that stimulates, or enlivens, the understanding as well as the sense of beauty. This is the case with the photographs in *American Photographs*. Conceptual thought is always in play but always under the sway of the viewer's apprehension of (formal) beauty, which is grounded in feeling.

As Evans strenuously insisted until the end of his life, he was an

artist; his pictures, he said, were not *documentary* but rather *documentary style*: they are concerned with play and stimulation—with understanding at the service of the imagination, not the other way around. His concern at any moment in his working life was with *what was in play*, which fact explains why he could, in the 1970s, take as much interest in a faded parking receipt as he had, in the 1930s, taken in an "icon of America," the face of Allie Mae Burroughs. For him each was what was then *in play*, and his change of interests can be described as a decline only by critics who assume that their hierarchy of values was his.

Evans's pictures do not instruct. They lead not to any final resolution, but rather to *final play*. It may be that this quality of final play, the radically unsettled *indeterminacy* that makes finding any resolved meaning in his work so difficult was, for Evans, "actuality in depth." This shifting, quicksilver view of things may be as close as he was able to come to *the real state of things*. Perhaps this marked ability (or inability) was a result of intellectual conviction, perhaps of the peculiar structure of his emotional faculty, perhaps of both. At any rate the skeptical stance so strongly evident in his work explains how he could insist on the holy unquestionability of the *Artist*, even as he was drawn to the hard everyday facts of his era. His work allies with specific fact and with the highest, most detached notion of art at the same time; his ideas are *aesthetic* ideas. In this respect his pictures come close to the famous (and famously obscure) pronouncement at the close of *Ode on a Grecian Urn*:

> "Beauty is truth, truth beauty,"—that is all
>> Ye know on earth, and all ye need to know.

For Evans (who as far as I know had no interest in John Keats), this dictum could be both marching orders and final estimate of his work. In his photographs, real nameable everyday things fall into order and find, in their relationships with one another and with the picture's con-

taining perimeter, a formal beauty rarely surpassed in the medium. At the same time these dense concatenations bristle with intellectual content—with ideas adhering to the arrangements and combinations the pictures record. These ideas lead the susceptible viewer on a merry chase, as they must have the photographer, considering how far afield from a cozy, controllable studio he was moved to go in pursuit of *beauty*: to factory towns, tenant farmers' shacks, to the sidewalks and subways of large commercial cities. But, stimulating as they are to follow, the ideas in his pictures never lead to sustained analysis, final resolution, or to the kind of settled conclusion about the state of things we might look for in the concluding paragraphs of a textbook. The conclusion—the "truth"—lies in the chase, in the *play*, in the pitting of a thing first against *this*, and now pairing it with *that*, all the while managing each individual balancing act with the skill and poise that *beauty* demands of art. The nineteenth-century artist Gustave Flaubert was a good choice indeed as role model for this "artist of the real."

Stefan Zweig used the word *war* to describe the relationship of thinking and feeling in the psyche of another great, flawed reporter, the Frenchman (who wanted to be Italian, and to speak conversational English as well) Henri Beyle, the writer who most frequently (but not exclusively) called himself, when he wrote, Stendhal:

[F]or fifty years the two psychic inheritances from Beyle and from Gagnon ancestry strove each with the other in Henri's soul, without either tendency being able to conquer. Feeling would at one moment overwhelm intellect, to be in its turn crushed by reason. This product of discord could never wholly belong to one sphere or to the opposing sphere. The intellect and the feelings are forever at war, and rarely have we been privileged to witness more splendid fights than on the battleground which goes by the name of Stendhal. . . .

He loves the precision of his intellect, clear-faceted as a diamond: he considers it a priceless treasure because it helps him understand

the world. . . . On the other hand, Stendhal loves his excessive emotionalism and his hypersensitiveness, because they rescue him from the stupidity and boredom of everyday life. . . . He realizes that it is the contact of his two opposites that generates the spiritual electricity, the sparks which tingle along the nerve fibers, the crepitating, tense, and stimulating vivacity, which we can still feel today on merely opening a book by Stendhal.

It is just this unresolved, unresolvable tension that keeps Evans of interest still, even though his immediate concerns are, as I write, between one- and three-quarters of a century old. He gives us the thirties as human history, without pedantry; at the same time he gives us a strongly felt reaction to that historical moment, without sentimentality. The constant clash of structured description and passionate (if suppressed) revelation makes his best pictures unforgettable and unlike the work of any other photographer who worked during his period on similar subjects. *Penny Picture Display* could not have been made by Alfred Stieglitz, Dorothea Lange, Arthur Rothstein, Edward Weston, or Ansel Adams. Its improbable beauty—"good" prints of this negative (whoever made them) reveal a tonal *melos* able to satisfy the demands of the most exacting critics—strikes most viewers and has inspired any number of later artists, not all of them photographers. But the picture's beauty is complex, involving not only form but also ideas, not only *melos* but also *logos*. It is by *thinking* about this picture, by thinking about what it shows, what those shown things mean, and how their meanings connect, in a way that is not *almost* literary but *almost exclusively* literary (if not for the arresting *opsis*, and the *melos* of its realization), that the picture's full force is felt. Leave out the qualifiers and parentheses I have found necessary to include, and read the sense of my conclusion in its most compacted form: the picture's *thinking* is *felt*.

War may not be the only mode of coexistence for thinking and feeling in a work of art, or in a temperament. Evans, as I have described him, habitually maintained an articulate but distanced, difficult relation to his subject, which in conversation he sometimes called "the hand of man." Caponigro is often able to seem almost eerily at one with his subject, establishing by means of his melodious views of rocks and flowers a seamless, meditative connection—a connection about which he cares to say very little that can be translated into words, as far as I can tell. Are there photographs capable of articulate examination, even analysis, as well as warmth of feeling, acceptance, even empathy? There are a few, but they operate on a dangerous middle ground.

Pure—we might say abstract—musicality leads directly to strong feelings which, to many, are their own justification. This is the realm of the purely (but not necessarily *simply*) beautiful. Pictures that deal with life can be thrilling when their tone is acerbic and hard, their structure of thought and reference subtle and complex. Such works continue to engage our minds even after we think we "get" them; they last. But pictures that deal with life in a way that is fond and affectionate—these are another, trickier matter. An abyss of sentimentality lies a short way down the thawing slippery slope descending from the icy, frozen summit. But skillful practitioners can keep their footing; think of Atget.

Or consider the pictures of a lesser-known, more recent photographer, William Gedney. For two quite brief stretches of time he worked in eastern Kentucky, once in 1964 and again in 1972. On both trips he produced pictures remarkable not only for accurate intuition and clarity of vision but also for the sympathetic interest his pictures take in the lives of the people in front of the lens, even in the fact of their very existence. The figures in these pictures are recognizable country folk, figures in a landscape (as well as in a society), but they are also, as this

photographer sees them, figures of stature, figures to be looked at with wonder, as if they were antique heroes or mythic figures cut from ancient stone.

Indeed, the gesture of the half-recumbent large central figure in one Kentucky picture does suggest the pose of one of the huge "river gods" in Lord Elgin's collection of marbles from the Parthenon. This massive figure is neither lying nor sitting up. The depicted gesture, though it stretches across the picture's whole frame, is not dynamic but balanced between a reaching out of the arm and a lying back of the weighty trunk; the legs, though extended, are crossed in an attitude suggesting relaxation. The figure could almost have just fallen onto its support, so balanced is it between rest and action.

The left arm is firm and rounded, but its power is suspended. Its use as an aid to the figure's partial rising results in an oddly delicate hand gesture: the whole limb is as much on display as in use. The head leans forward to aid the rising, like the arm; the taut sinew under the neck's skin suggests effort, but the facial expression is impassive, even reflective. The eye meets neither the photographer nor the other figure just offstage, but looks somewhere in between. The lack of eye contact with either of the other two implied characters adds an element of abstraction or disconnection to this figure's character and presence. He is not quite fully engaged in the action the picture represents, not fully a part of its "picture story."

Only his extended right arm embodies a gesture unambiguously forceful and dynamic, a gesture extending across one-third of the picture's long dimension to connect with the other character, who is represented only by an arm similarly extended from the opposite direction. This single unequivocally effective gesture amidst so much suspension and balance recalls to the thoughtful viewer (and likely would have recalled to an artist as widely read as Gedney, an artist who appears in a photograph from his student days with his sculpture of a

classically proportioned figure still on its modeling stand) two other gestures: the touching hands of God and Adam, *visible* in the Sistine Chapel, and the passing of fire/the torch/the relay baton, *knowable* from the Prometheus myth, old even in Hesiod's time.

In common speech we often say of an arresting sight or picture, *It made me look twice.* This picture makes the viewer look twice, in two ways if not at two times. An alert viewer with a lively associative mind *looks*, and sees, in the first place, this particular man, in this place in 1972, hugely filling this picture with arresting gesture and with his thick, muscular body. The picture goes head-on and directly toward a physical subject, approaching so close its viewer can almost touch and smell its immediate, immense presence. The viewer sees this but also sees, in the figure's odd gesture, allusions to other, familiar gestures, references to ancient familiar myths that cling to this picture like resonant overtones, or lie across it like a shadow. To use another common saying, Gedney's picture presents the man as *larger than life.* Exactly so: we see *that* man, a speaking likeness of the Kentuckian depicted, but we see him as *more* than just that. The picture gives him a lineage that is mythical, even divine.

This gesturing figure is of course not nude but clothed, clothed not in the sandals and "classical" drapery even the hardheaded realist Eakins occasionally chose for his models, but in heavy black shoes, ribbed white socks, factory-hemmed pants, and a dark two-pocket short-sleeved shirt with heavy seams suggesting a fabric nearer to khaki than long-staple cotton. His phaeton is a Pontiac or Buick (I think), ten years old at least, probably more, with scratched, chipped paint. The Arcadian glade is overgrown with high weeds, its trees untrimmed. The socioeconomic information the picture provides identifies its central character as a member of the struggling working class.

This identification, plus the dense crop of low-parted dark hair framing a thick nose and lips and a heavy chin might brand this char-

acter as a dismissable loser, a fellow mildly picturesque to some per-
haps but hopelessly, irretrievably doomed in any informed, savvy un-
derstanding of how the world really works. Imagine him in a
photograph taken from farther off, on a street drab but no more dis-
tressed than the car he reclines on, walking in the direction indicated
by a large arrow sign on a wall above him, beyond his sight and aware-
ness. Or imagine him pulled or coaxed or bribed in front of a plain
white backdrop, in hard, bright daylight, and asked to address a large
camera manned by a nattily dressed photographer and his assistants. In
either picture this working-class (at best) guy could easily appear at a
disadvantage, one of the world's victims, a fool in a world made up of
fools and knaves. A viewer could easily be enlisted to join the hypo-
thetical photographer's perspective and write this character off as a sad
end waiting to happen.

Such a viewer's conclusion would be computed, thought out ac-
cording to everyday thinking by adding up the bits of evidence shown.
The accomplishment of Gedney's picture is to undo this everyday
thinking with a thinking of another kind, the thinking of the viewer
when he follows the lead of allusions the picture suggests. By prompt-
ing thoughts of river gods, of the awakening Adam, of the Promethean
transfer, the picture overcomes the everyday canny thinking we do
when we size up a stranger as he approaches on the basis of his gait,
his haircut, his clothes, and (if he speaks) his accent. This picture
shocks us out of the realm of practical everyday thought into a realm
where wonder and awe operate. In the world this picture creates there
are no forgettable losers, only figures worthy of our attention, arresting
figures alive with significance, numinous figures. Led by the picture's
thinking, the viewer of this world is invited to suspend his everyday
judgments of the damning sociological evidence laid before him, and
freed to concentrate on the richness of the ultraphysical thick beauty
of the central figure's distracted visage, whose heavy nose, lips, and
chin command the same kind of fascination and play to the same in-

ability to look away as the ruined face of Anthony Quinn in the role of the battered, addled pugilist in *The Harder They Fall*.

Gedney kept a commonplace book, a kind of journal whose entries consist largely of quotations copied from his readings. One of his entries notes as a "possible book title" a fragment from a poem by W. H. Auden: "short distances and definite places." The words are from "In Praise of Limestone," a poem which has a connection to the picture of the man on the car. Both attempt a similar feat: transferring our best reverence, our fondest regard, our capacity for wonder from the heroic to the everyday.

No poet as ambitious, as learned, and as alert as Auden would likely write about stone without having in mind, at least being aware of, Keats's great sonnet on stone—or, more accurately, on *looking at* stone—"Upon Seeing the Elgin Marbles for the First Time." Auden wrote of limestone, "a stone that responds," a stone able to melt and wear, a stone without the "godlike hardship" of Keats's marble. Auden is concerned with landscape, a setting for a *possible* life—that is, a life which can be lived successfully, rewardingly—rather than with antique sculpture, the instructive (inspiring, but daunting as well) depiction of life lived at its highest and most heroic. But in the poem's survey of landscapes he fears, Auden's speaker lets us know that sculpture is on his mind:

> The poet,
> Admired for his earnest habit of calling
> The sun the sun, his mind Puzzle, is made uneasy
> By these solid statues which so obviously doubt
> His antimythological myth; and these gamins,
> Pursuing the scientist down the tiled colonnade
> With such lively offers. . . .

Edward Mendelson, who has faithfully reconstructed not only what Auden was reading but also what he was thinking at almost any

moment of his career, sees a reference to Wallace Stevens in these lines. Indeed, the Stevens of "Notes Toward a Supreme Fiction" (published in 1947, just before Auden's poem was written) dwells on "The inconceivable idea of the sun," and describes the statue of a man which "Changed his true flesh to an inhuman bronze." Stevens's tone in general is abstract, remote, coolly cerebral like the cold, hard marble form of antique statues.

Yet Keats may be lurking behind the scene here along with Stevens. The Keats of the Elgin Marbles sonnet is also a poet with earnest habits, also made uneasy by solid statues:

> My spirit is too weak; mortality
> > Weighs heavily on me like unwilling sleep,
> > And each imagined pinnacle and steep
> Of godlike hardship tells me I must die

Further, his mind is indeed Puzzle, full of "dim-conceivéd glories," breeding an "indescribable feud," a "most dizzy pain":

> Such dim-conceivéd glories of the brain
> > Bring round the heart an indescribable feud;
> So do these wonders a most dizzy pain

And the sun—the sun that casts "shadows of a magnitude"—is the final image of the poem. Keats and his marble are not farther off from "In Praise of Limestone" than Stevens and his cerebral puzzling.

Auden's poem describes, on the one hand, the "solid statues"—the imagined pinnacles and steeps and the inhuman bronze—and the scientist in the tiled colonnade, the exact observer, some Winckelmann perhaps, a figure able to share in Keats's thoughtful swoon in the face of Grecian grandeur that mingles with "the rude/Wasting of old Time." On the other hand, Auden notes the gamins who pursue the scientist with such lively offers. Are they related to the young male, mentioned earlier in the poem?

> . . . the nude young male who lounges
> Against a rock displaying his dildo, never doubting
> That for all his faults he is loved

This image could describe any of a number of photographs made by Wilhelm von Gloeden, who photographed Sicilian youths in "classical" poses prominently displaying just the equipment mentioned by Auden. These photographs are art of another kind, art for a narrow audience of connoisseurs—the "knowers" (referred to by Oscar Wilde) who valued photographs of naked boys, like photographs (including work by von Gloeden) acquired by Auden's acquaintance Magnus Hirschfeld, who (until 1933) maintained his collection of photographs in Berlin as a part of an institute of sexology. These works of art are not the severe classical marbles that daunt us to swooning but another thing, linked to Mediterranean classicism but "lively," linked also to the offers of the pursuing gamins. Rather than the heavy press of unwilling sleep—or a sun which must "Be/ In the difficulty of what it is to be"—these offers promise life, hot sexy life, broadly physical rather than abstractly intellectual, the *carnal* rather than the *mortal* aspect of mortality.

Gedney's photograph is no simple essay in eroticism, no more than Auden's poem is only about gamins romping amid the ruins. But an erotic strain is for both one of many motive forces enlivening these attempts to translate the power of the heroic into the present everyday. In Auden the antique is referred to, but the high standards associated with it—the "godlike hardship" of Keats—are enacted in the verse, in line after line, in the complex, perfectly balanced flow of words and images, allusions and sounds. We hear a poet as accomplished as Keats, one up to the highest standards of the past who yet has chosen to update his interests: in this poem we read of no gods, goddesses, and wood nymphs, but rather of very human behavior in a backward out-of-the-way place, of gamins, and of a listening person addressed as *my*

dear. Auden does not reinvoke the heroic but rather shifts the field of discourse; his subject is hospitable limestone landscape, not daunting marble sculpture. He doesn't look for power in the old places so much as move power on along to other concerns, though he lets the reader know he knows how great that old power was, both by telling reference and through his practice.

Gedney keeps the heroic sources closer to mind, even as he looks hard at the immediate present, the real-life man whose face is six feet from his lens. His picture uses the components of photographic seeing as carefully as any picture in any of these essays, but with a stunning lack of self-awareness or pride of achievement. A viewer can look at this picture with interest for a long time without dwelling on the skill required to make it, which is almost self-effacing. The photographic strategy used here is a sure, thoughtful embrace of a piece of the physical world. The mythic overtones come as directly and as naturally to the photographer as does clear description of the figure in front of him. Each is a part of his thinking and thus a part of his seeing, a part of his self; both come into play when he encounters a moving presence.

Like Auden, he is concerned to keep the experience of his subject *real*: possible, available to a person alive in his present, felt and not thought only. The present-day Kentuckian and his mythic aura exist for the viewer at the same time. They are the same. There is no superimposition of the latter onto the former, and no self-conscious aspects of the artist's performance to tip his hand or call attention to what he is doing. What he is doing is seeing his partner in an encounter, and for him seeing involves thinking and feeling together. The Kentuckian reclining on his accommodating Pontiac and Auden's hospitable limestone landscape both stand in similar relation to the impossible Elgin Marbles. Both aim at a present-day, possible, real occasion for the strength of feeling associated with the heroic.

Cigarettes, cars, and ragged mountain foliage fill out the world of Gedney's pictures of Kentuckians. The outstretched arm holding a

light (this man is offering the butt of his cigarette as a light, not as a smoke to share) parallels the chrome strip adorning the side panel of the car he reclines on. These two pictorial elements are in harmony, not in conflict. Gedney's close observation of his subject is in harmony, not conflict, with his affections. He seems to like, even to wonder at, what he sees. The camera lens is no more than three feet from the foot in the lower left-hand corner of the picture; he is so close to the subject-person that he is actually a member of the group, as close to the cigarette offerer as is the cigarette taker. The viewer sees the foot, on his left, from the right side; the same viewer sees the car windshield, on the right side of the picture, from the left. The picture's view is from *within* the action it records.

Caponigro's perspective rarely calls attention to itself: some pictures are close-ups, but often he stands at a middle distance. His closeness is emotional rather than spatial. Evans's perspective often approaches the architect's orthographic perspective: he sees every element of his picture, center, left, or right, straight on, as if from infinity, from immeasurably far away. The involvement and the intimacy of Gedney's seeing is not often within Evans's range. Yet somehow this icy, infinite perspective helps Evans's pictures reach the level of the highest art. His "classical" detachment allows him to inhabit the chill, rarefied air breathed by his acknowledged model Flaubert. His work has a stature not often achieved by photographs.

Stature: maybe an unquestionable good or maybe not. Certainly it has been one goal of the most ambitious (and best-respected, if not best-loved) twentieth-century artists. The father of five down the street, the diligent salaryman who supports his brood, pays his taxes, and volunteers in the town literacy program in his spare time may warm our hearts, but he also may be something of a bore when he talks or when he shows his snapshots. Whom do we, as a culture, admire as artists? Eliot. Joyce. Picasso. Evans. Small wonder the *exposé* celebrity biography is having such a vogue; there are so many human shortcomings to

expose in the lives of the artists we most admire. Would you like to have Andy Warhol or Jackson Pollock as houseguest for an extended visit? We value most not those artists who reassure us that the world is a good, safe place but those who make us question what we think we know. More accurately, we (as a culture) *begin* to value them once their restless questioning no longer poses an immediate threat to our present well-being. Van Gogh was puzzling, even threatening in 1900; in 2000 his works bring the highest prices at auction. The most alert of us today may feel warmed by his fire but not burned.

The cooperation of thinking and feeling impresses less than the war between thinking and feeling. A decent sympathetic vision seems smaller than precise, acid, distanced analysis. Perhaps we feel— perhaps rightly—that an alienated, skeptical vision, particularly one guided by a sharp intelligence pricked on by slights real or imagined, can, in questioning the fundamental assumptions of the world we know, do greater service than talents content to celebrate that world's accomplishments, or even its mere existence.

Vladimir Nabokov wrote (in a passage copied by Gedney into his commonplace book) that art consists of specific details and not of the general ideas Americans are taught from high school to look for in works of art. He is unquestionably right: the difference between art and commonplace expression is the last 20 or 10 or 5 percent of rigor, the thoughtful taking care of details of craft that makes a poem or a picture *exactly* right and not just sort of on some right track, the difference between a *human interest* picture and Henri Cartier-Bresson's picture of Jawaharlal Nehru and the Mountbattens on August 15, 1947, with its near-perfect balance of setting, gesture, facial expression, and historical resonance. But it is also true that once a work of art has earned its stripes, has qualified as real art and not just well-meant ranting, it enters into the realm of *thinking*. Even if its motives and methods have mainly to do with feeling, a well-wrought work of art takes a stand, establishes a presence, becomes a point of reference. A picture like

Caponigro's, or Evans's, or Gedney's earns the right to communicate with the history of ideas—not by default, because (like some of the plays of Beaumont and Fletcher) their only interest lies in the contemporaneous ideas they might reflect, but by virtue of positive accomplishment, the forging of experience into a kind of meaning, as in Keats's sonnet on seeing the Elgin Marbles. When words, or shapes and colors, or mimetic images, or the elements of seeing, are worked relentlessly to give up all their content, expressive as well as significant, the result is a *thinking*, a statement qualified (in Wordsworth's words)

> To hold fit converse with the spiritual world
> And with the generations of mankind
> Spread over time, past, present, and to come,
> Age after age, till Time shall be no more.

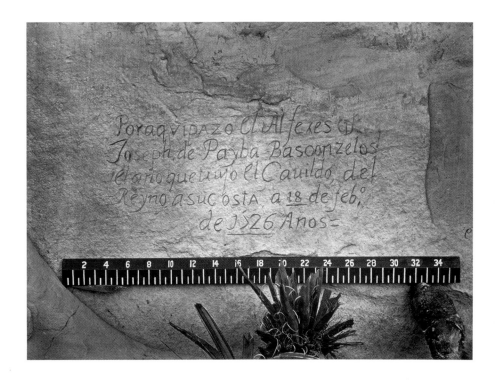

Timothy J. O'Sullivan, *Historic Spanish Record of the Conquest, South Side of Inscription Rock, New Mexico,* 1873. Courtesy George Eastman House.

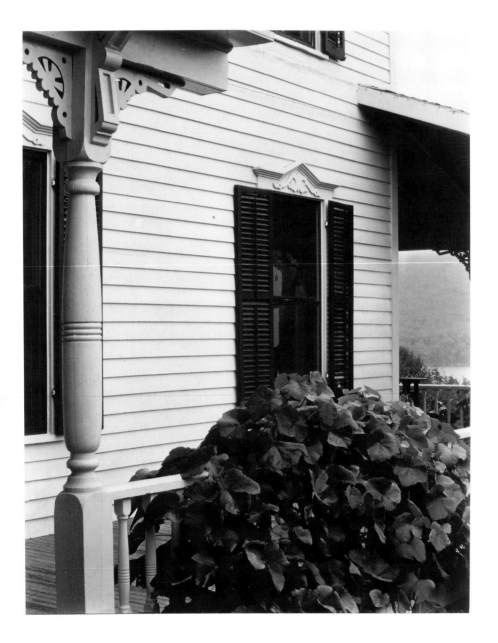

Alfred Stieglitz, *Porch with Grape Vine, Lake George*, 1934.

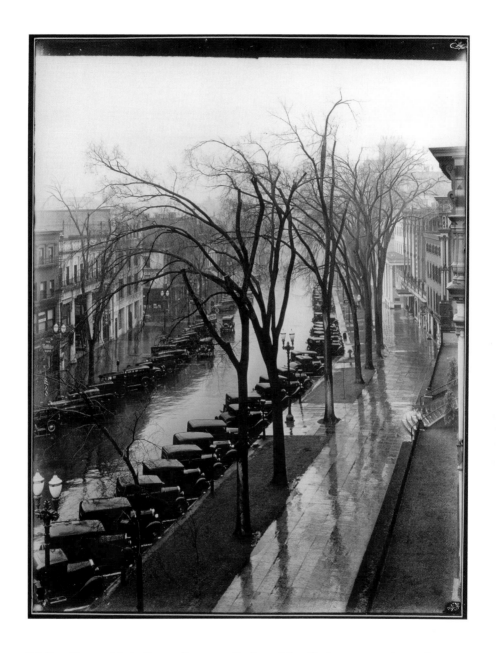

Walker Evans, *Main Street, Saratoga Springs, New York*, 1931, untrimmed print of entire plate.

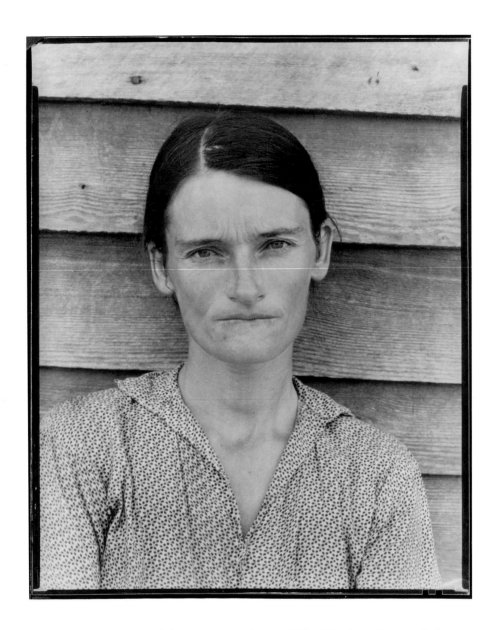

Walker Evans, *Alabama Tenant Farmer Wife* [Allie Mae Burroughs], 1936, untrimmed print of entire plate.

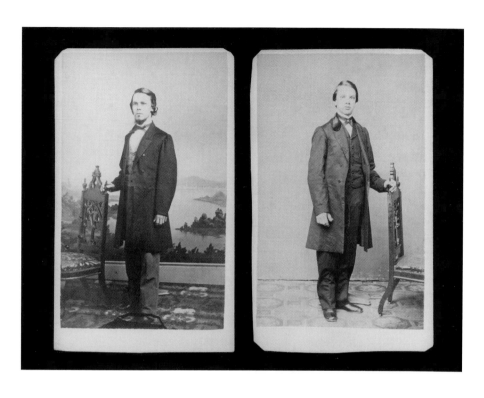

Photographer unknown, two cartes-de-visite.

Paul Caponigro, *Kilterman Dolmen*, 1967. Reproduced courtesy of the artist.

Walker Evans, *Penny Picture Studio, Savannah* [title used in *American Photographs*], 1936, untrimmed print of entire negative.

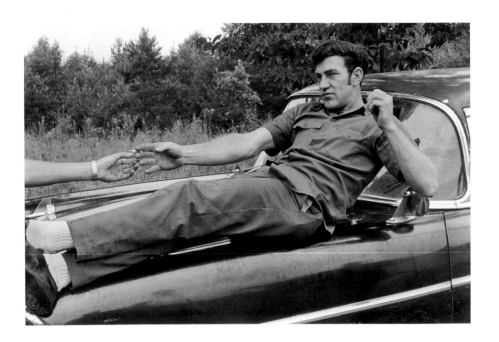

William Gedney, Kentucky, 1972.

The Light on Eighth Street

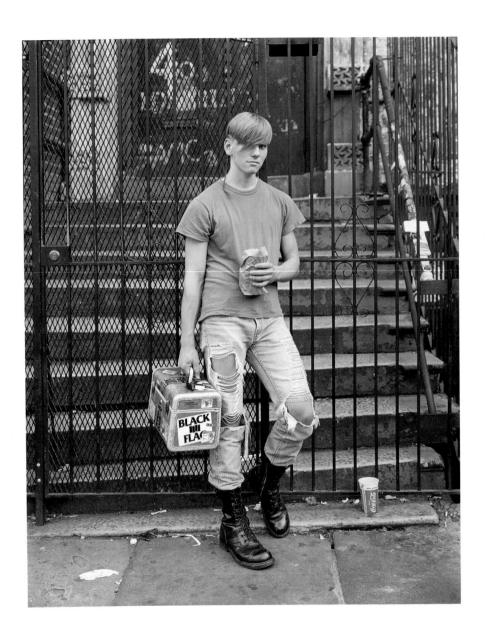

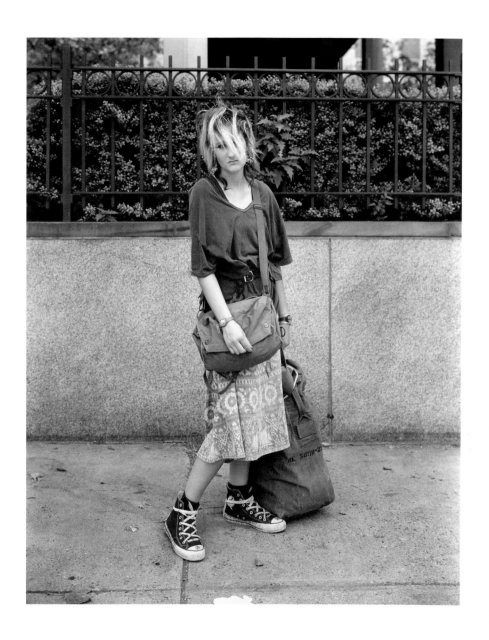

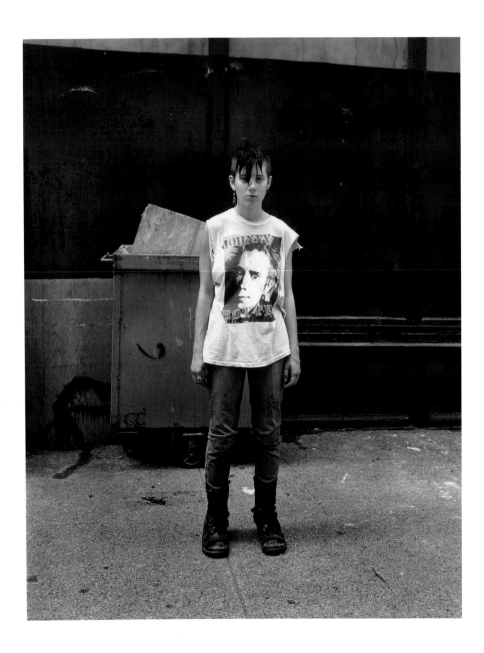

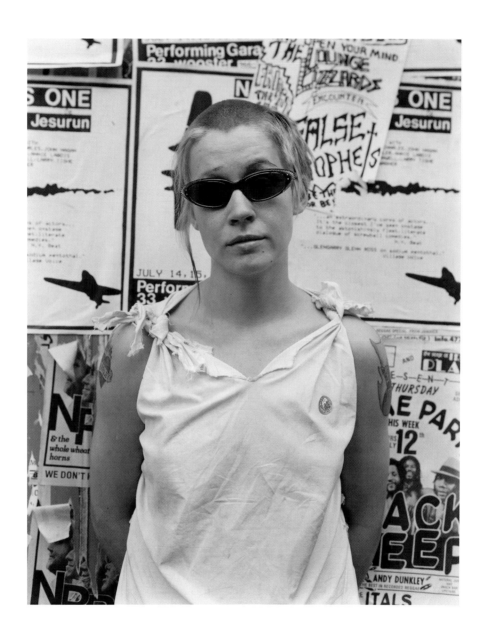

4

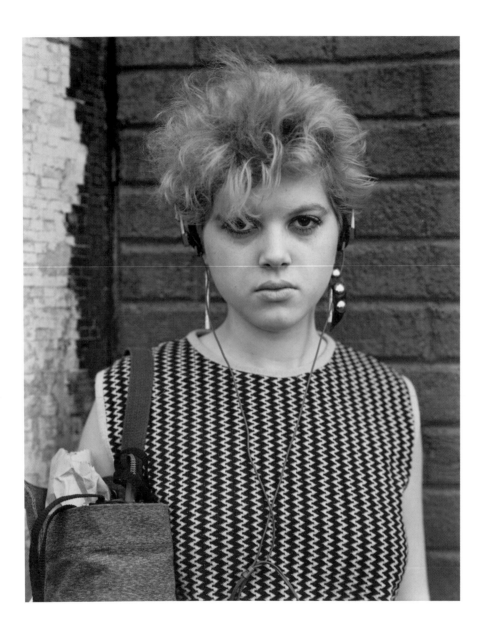

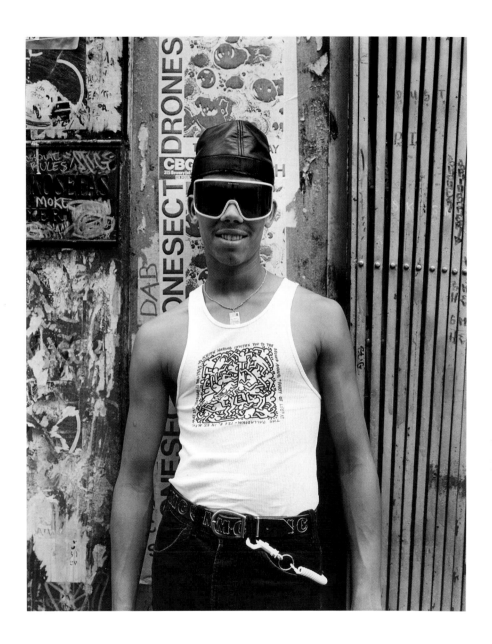

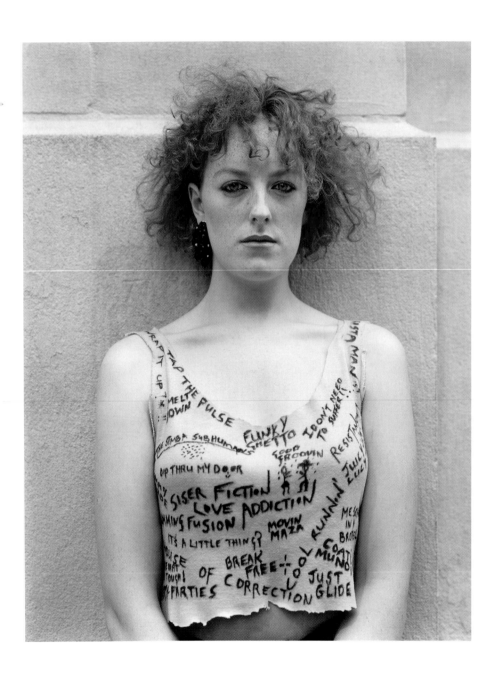

9

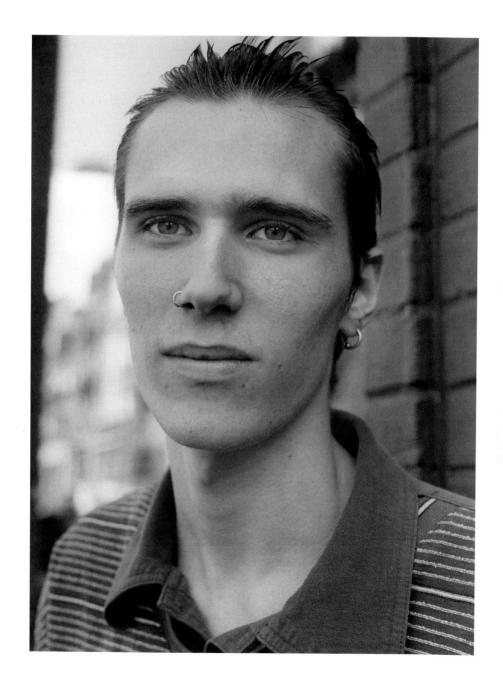

12

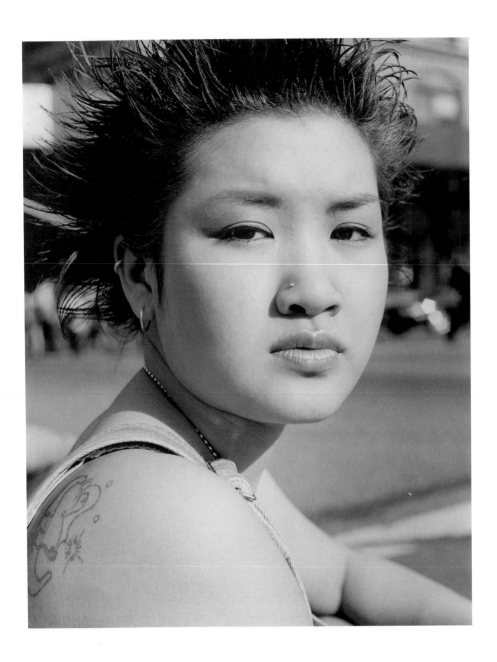

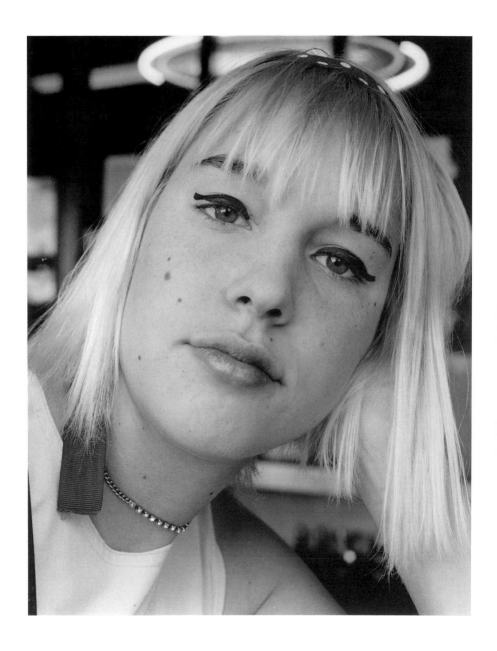

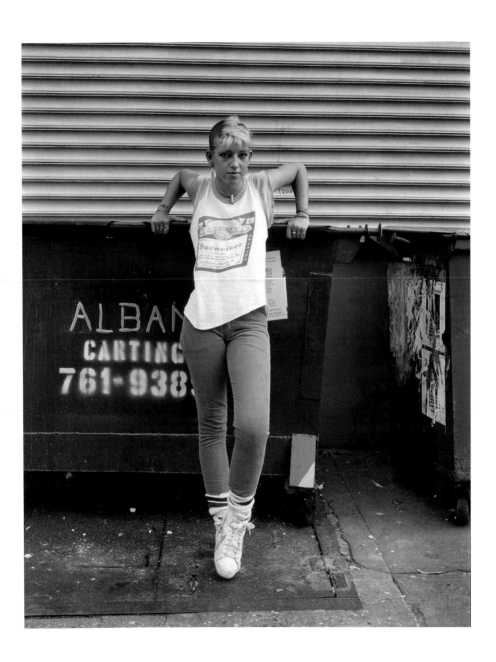

15

Like most Manhattan crosstown streets, Eighth Street cuts an east-west canyonlike gash through the accreted superstructure of the city. Its fifty-foot-wide strip of pavement runs straight and level between the rows of buildings lining its north and south margins, each row a varied assortment including some skyscrapers, balconied apartment buildings of twenty or more stories, but mostly smaller structures, houses four to six floors high. The flat clifflike façades of these row houses rise, on average, about fifty feet from the level of the street below, the sharpness of their ascent softened somewhat by the stoops jutting out at street level on some blocks, by the rows of ginkgo, locust, or plane trees found along a few stretches of sidewalk, and by such street furniture as cast-iron fences, trash cans, and heating oil fill-pipes. On blocks lacking these distracting features, the ascent of the façades seems sharp indeed: the street's level horizontal changes abruptly to a severe vertical, a looming flatness of brick and stone, the barrier that marks, in cities, the hard border between public and private space.

Probably this structural configuration leads to consequences of interest to urban sociologists; without doubt it has great effect on the *light* in which any such consequences might be observed. The canyonlike shape of the street and its flanking walls act as a great modulator of light, a huge arrangement of conduits, baffles, and reflectors. In cooperation with the sun, as it appears in different seasons and weathers, this undesigned arrangement supplies an astonishingly wide array of lighting effects to the unending urban fair that takes place on the street below, from dawn to dusk, every day of the week, the year round. The

activity there is, as it was when I first saw it, a great spectacle that presents an almost unimaginable range of human appearances and behaviors; the street that contains these provides, in turn, a nearly limitless variety of illuminations to view them by: spot light, soft light, half light, directional light, flat light, light with high-key accents, broad light that illuminates a whole block, pencils of light so thin they strike one member of a couple and not the other.

Eighth Street, in the New York City borough of Manhattan, runs without interruption from Sixth Avenue, its western end, to Avenue A on the island-borough's east side, where Tompkins Square Park blocks its way. For about half its uninterrupted length—from Third Avenue to Avenue A—it is called St. Mark's Place. Maps of the city show the street to continue beyond Tompkins Square Park as East Eighth Street, on to Jacob Riis Park on the East River, but I have never walked these few blocks.

For thirty years that I know of, probably longer, much of the street-level real estate on Eighth Street has been given over to the kinds of stores I noticed on my first visit, small shops supplying the wants of youth counterculture. Hippy, Aquarian, Psychedelic, Biker, Mod, Punk, New Wave, New Age, Grunge, Multi-Culti, Retro, and even some Yuppie goods have been offered in abundance by dozens of shops along Eighth Street between Sixth Avenue and Avenue A. Cheap jewelry, recorded music, clothing and accessories, restaurants, snack stands, bars, and (more recently) body-piercing and tattoo services attract most visitors, though some like me come just to look.

Like Venice, Italy; Venice, California; and Coney Island, Eighth Street puts on a rich show for sightseers. No buildings here approach the architectural distinction of the Doges' Palace, the elaborate beauty of St. Mark's Basilica, or even the bright fantasy of boardwalk façades. Nor are there prominent concentrations of picturesque freaks to compare with the bodybuilders and bikini-clad roller skaters of the other Venice. A search of the neighborhoods touched by Eighth Street might

turn up a few collections of exotic deviants—a Hell's Angels' club-house, for example, an apartment full of menacing skinheads, or per-haps even a coven of Satanists—but these are not what is most commonly seen by a visitor who walks this street in the daylight of a typical afternoon. Odd-looking individuals turn up from time to time, but for the most part a sightseer—a looker—on Eighth Street sees a large, diverse group of more or less average young people looking for amusement: fingering gaudy merchandise, trying out new styles, play-ing with possible identities, testing the shallow waters of extravagance. Eighth Street has been an important locus if not a center of youth culture for thirty years or more, and a good place to watch the young. Their experiments interest, puzzle, touch, and move me in many com-plex ways, but the attitudes and outfits these experiments involve ap-peal initially, and primarily, to my eye.

I still visit Eighth Street, and in recent years—over the last five or six in particular—another attraction has caught my notice and become a steady source of pleasure: the varieties of light there, and in particu-lar a large shaft of sunlight that plays across the street's eastern blocks as the sun moves toward setting during the late afternoons of clear summer days.

After mid-June, clear summer days are rare in New York City, most years until late August. As summer heat sets in, humidity builds up, and hazy days are common. Typically, heat and humidity build for days or even weeks, and then a thunderstorm clears the air, leaving a day or two, or sometimes a single late afternoon, of clear sky and hard sunshine. On these clear late afternoons the sunlight takes on a liquid presence, becoming almost as much a thing to look at as to see by. On these days—there are perhaps eight or ten a summer—it can be said, to take the surface sense and ignore for now the context and underly-ing meaning of a long-dead poet's perfect image—on these uncom-mon summer afternoons it can truly be said that *brightness falls from the air.*

2

I FIRST SAW Eighth Street in 1967, and everything about it attracted my eye. At ground level the street was (and is) mostly shops, and their array of merchandise struck me as outrageous and astonishing: windows filled with elaborately inventive and colorful drug paraphernalia—water pipes, air-cooled smokers called bongs, cigarette papers with pirate or gypsy heads on their packages, decorative patches to sew on denim jackets, glittering crystals and prisms, laboratory glassware, balances, and vials of white powders. Other windows were crowded with stiletto high heels and absurdly impractical platform-soled boots, dozens of pairs in a single small window.

Some shops offered then (and still do) wild clothing and jewelry, along with other adornments suitable for rock stars. All this interested me, to put it mildly, but did not tempt: just looking, we were taught (as children) to reply to department store clerks who offered to help. In 1968 I went so far as to buy a used leather jacket, which I wore one time (wearing it on a flight from Mexico got me strip-searched in a Chicago airport), but most of the small amount of shopping I did in those years was farther uptown, in stores I had read about since I began to look at national news magazines.

Framing these shop windows was (and is) a motley urban architecture I might now call unexceptional but liked to look at then, thirty years ago. I was drawn to it because it looked substantial, and it was old, much of it from the last century. Most of the Houston I grew up in was built after 1930, the part I knew with limited ambition and dubious taste. On Eighth Street I saw, for the first time in such profusion, cast iron that was structural, rusticated stone, and carved faces and figures on stoops and cornices. I noticed singular, quirky details: a patch of bright terrazzo installed at some forgotten past time as an undulating modification of storefront plainness; an old bronze plaque, now

tarnished and graffiti-covered, advertising the long-gone office of a firm of immigrant lawyers on a block taken over years ago by shops and restaurants catering to fully assimilated New Yorkers.

I saw this district of row houses and apartment buildings as truly urban: a dense, compacted mass, thrillingly different from the thin horizontal spread I knew from the suburban-style cities of Texas. There, cracked sidewalks and scraggly patches of ignored grass covered the slack stretches between the low, drab buildings housing auto parts stores and 7-11s. Cars pulled in and out of parking lots for long hours of seasonless afternoons heavy with humidity, heat, and boredom. Here bookstores and cutting-edge music shops competed for attention with T-shirts and posters displaying sharp, irreverent jokes, a hip wit suitable no doubt for the energetic, ambitious young people who filled the small apartments upstairs. The seasons changed, and people walked, filling the sidewalks, at a brisk pace. Here the buildings seemed real, old, significant.

As much as it pleased me to look at them, the buildings were never the main thing for me in Eighth Street; neither were the shops and merchandise (though I liked to look at them a lot) ever the focus of a visit to the area. The *people* I saw there—those energetic young experimenters who lived in the apartments upstairs, or maybe wanted to— were, and are, the subjects of my greatest and most lasting interest. By 1965 or so I had fallen into the habit of thinking that many of the people I had known growing up were dull: my law-and business-school oriented fraternity brothers, and the hardworking parents of my friends. (One father worked in automobile body shops; another as a traveling sales representative for novelty companies; a third taught driver's education in a small-town high school.) I was restless and on the lookout for something beyond what I had known. I wanted scope for the imagination, though my idea of imagination then had more to with the ambitions of Fitzgerald's characters than with Coleridge's philosophical musings.

Those I saw on Eighth Street may have endured lives that were difficult, unsatisfying, or even dull, but these people, especially the young ones, were certainly not dull to look at. They had energy for dressing up, and they were driven to display themselves in an attempt to discover, or maybe invent, who they thought they might be. When I first saw this street, dressing up might involve surplus army jackets and ammunition pouches, perhaps with an American flag draped somewhere. Chinese worker shoes and other accessories from East Asia began to show up, followed by odd bits of Africa and the Caribbean. In the late seventies *punk* hit like a bombshell, directing the most adventurous sartorial experiments for a decade or more. Recently flashes of movie-star glamour and parodic versions of couture have come into vogue. Actual complete costumes—pirate, Edwardian dandy, etc.—are rare but appear from time to time.

Bits and pieces, at least, of most of the styles I have ever seen are still visible; their wearers still make a gaudy, eclectic parade in the street now, every day, from late morning until nightfall and after, as they did in 1967. This street is a place for the young, a bazaar of delights, a place where things can be bought but also worn and shown off. I was not one of them, at least not one *with* them, even in 1967— not *that* young, certainly not so prone to uninhibited experiment, but even so I felt a wistful, pleased kinship with the profligate display of good looks and well-being, the heedless, relentless search for shallow, temporary pleasure that is the common theme of the activities there. I didn't want to know the people then, when I first saw them, even though I was part of no other set in the city. I had no wish to meet them, to do things with them, or even talk to them: I wanted to *look at them*.

The more I looked the more of interest I began to notice. Often, in thinking about some sight I had seen seconds earlier, I would wonder about a detail I hadn't noted clearly and frame a question to be answered by the next look. I tried to learn where to walk, when to go

there, how close I could stand without destroying what I was interested to observe. Looking became an active occupation.

My habitual look is a direct inquiring stare, a look sometimes returned but more often one-way. In a busy street such a look may be barely noticed by its target. Even when this look is accompanied by a request to take a picture, the event may not be remembered for long. At an exhibition of my photographs in 1982, I watched a girl I had photographed three years earlier look at her own head-and-shoulders portrait. Her friend had led her to the picture, but the girl was unable either to recognize the likeness or to remember the picture-taking session, even though I had stopped her on the street, and she had agreed to stand still for two minutes and address the lens of the large tripod-mounted view camera I was carrying. The moment was important to me but, clearly, not to her. It was only a small part of her day's experience and passed through her scattered attention without leaving a trace. For me it was the only picture I got during four hours of walking and carrying. The two minutes of our contact was, for me, a focused, strenuous encounter requiring as much as I could muster of will, tact, speed, dexterity, concentration, and clarity of mind.

The average population of this street (the self-absorbed young experimenters) is especially disinclined to notice, or to mind, the kind of attention I give them. The large cameras I favor attract some notice, but on Eighth Street the presence of even a huge, unusual camera is rarely the most noticeable feature of street activity. A scowling, bandana-topped man with a video outfit (including a light on his large camera and professional recording equipment carried in a milk crate strapped to his back), stumping along Ahab-like with a full cast on one leg, worked the same streets I did for a while in the late seventies, and his presence rendered me virtually invisible. With such distractions, and with hundreds of people crowding a narrow strip of sidewalk between shopping stalls, animal rights protesters holding up large color photographs of vivisections, painters hawking their work, declaiming

street poets, and change-bummers on one side, and a street jammed with loud bikers and aging, souped-up Acuras with powerful sound systems on the other, I can look even at close range without disturbing the person I watch. (By *disturbing* I mean to refer both to annoying or bothering that person, and also to causing an unwanted change in the behavior I want to watch.)

When I use a camera on a tripod, my subject looks at the camera rather than at me. I stand a little to the side and watch a person who is trying to pay attention to the camera's lens. Quick self-conscious nervous glances sometimes shoot uncertainly toward me, but the situation, as I present it, requires the subject to look at the camera's lens. Only those who are willing to cooperate agree to stand for me, so they usually follow my instructions and look at the camera rather than me.

A large camera on a stand stops time for a brief moment. For a few seconds the chaotic hustle-bustle, even the raucous *sounds* of the street become so irrelevant as to disappear while the chosen, willing subject concentrates on the lens, trying to hold still; while I keep up a stream of encouraging talk to keep the subject still, stiller than almost anyone thinks he or she needs to stay; while I wait, during these few seconds of precious stillness, for an opportunity to press the shutter release. A flicker of light flashes on the film for a fifth of a second, and an image detailed beyond imagining registers on its eighty square inches of surface. Put into digital form, all the detail from one picture could not be contained in a thirty-megabyte file. Some of the people I photograph may remember what this large wooden box of a camera looks like, but very few, I think, would recognize me without the camera.

With a smaller, hand-held camera, I face my subjects eye to eye, but the optical system of the camera interposes, working like a one-way mirror. With my (right) eye bent to the eyepiece, I see the face in front of me as if through a telescope, or microscope; the subject sees the top of my bowed head and a half-pound of German optical glass. If I am close enough (I usually am), the subject may notice his or her face re-

flected in the front lens element, right side up but reversed, and bloated like the image in a funhouse mirror. This smaller (but far from miniature) camera speeds things up, but not much. Time on the street still stops, for a few seconds (*Stand still for a moment, will you? so I can get a good look at you*), even though the actual exposure takes only a couple hundredths of a second.

And just at this brief moment of exposure comes the most exciting part, the least predictable. Always hoped for by now, but always, when it comes, as unexpected as it is undeserved, the greatest thrill is *the look back*, the answering stare, the rising to the occasion, the star's response to a close-up, a response frequent enough to keep this practice miraculous still, after many years. A cinder or ash, a dormant coal bursts into luminous flame for a brief, dazzling moment, a few seconds. And then the friend to be met shows up, the waiter brings the check, the remembered errand is run, the street sounds and distractions return, everyday life resumes. No names and addresses are exchanged, no print promised; the subject walks away, usually for good.

I walk the same streets over and over, though, and sometimes I see a subject again, later the same day or maybe weeks or months later. I still (in the early twenty-first century) see faces I watched in the 1970s, recognizable to me even after twenty or more years of changes in dress, hairstyle, muscle tone, and identity. A few dozen or hundred faces I've watched on the street for a few seconds or minutes have become permanent parts (barring illness or injury) of my mental furniture. Why they stay with me, and why I keep looking at yet more, I cannot easily say for sure—certainly not with the same confident force and clarity I might attempt in discussing a picture made by someone else, sixty years ago. But these faces are as undeniably *there* in my mind as the hundreds or thousands of other faces are *there* in the prints I keep in acid-free storage boxes, bits of data for an unwritable history, fragments glimpsed during my rapid blinking stumble through a flick of sunshine.

Why do I keep going back to look at and photograph these faces and figures? What results from these brief, strenuous encounters? Part of a possible answer to these questions concerns a link, a tenacious connection to the subjects I watch. But not a biographical link or real-life connection.

Even in the 1960s I was outside my subject, and the passage of thirty years has only increased my separation from those I watch, the young ones. Perspective and a reflective cast of mind are gifts most generously given in the second half of life, where I find myself now, but even as grateful a recipient, as enthusiastic a devotee of these gifts as I am can be brought up sharply by a casual, heedless shout or laugh, or by a sudden gesture—a thin, smooth hand, say, raised in a quick, fluid gesture to brush a wisp of hair from a face unmarked as yet by strain or worry, by nights of fitful sleep, or by the touch of time. Suddenly that hand, that unmarked face, is me, or closer to me than any real-life connection could ever bring it. Mysteriously, that young stranger and I are linked.

We are young, the stranger and her happy cohort proclaim with every move and utterance; we enjoy the pleasures of our youth, and we will always be young. The grey spectator sees something else, another version, one more realistic, and inescapable. In that young life he sees his own past, gone, now a space away. Ahead—not yet, but an easy distance off, the bright scene fades; *all* bright scenes, all brightness fades to a final dark. This waiting dark, hidden from plain sight (along with so much else) within the surfaces he watches, is a part of what the grey spectator sees. Whether flashes of tragic insight or spells of mere self-pity, these glimpses are moments of contact with something large and real, something powerfully felt, a thing improbably, morbidly attractive even as it unsettles.

And yet—another facet of this part of a possible answer—the same spectator can find himself so engaged by a sight that the *thing seen* crowds all else out of mind; consciousness, for a time even the whole

of being is taken over by this *thing seen*. At such times, energies for paying attention, usually diversely scattered to the ears, the feet, the back, the kidneys, the heart, the memory—parts that hurt or fail, and distract—are all rashly, desperately, thrillingly invested in one organ, the miraculous human eye, the window out of the body (and out of the self): the receptor that takes in, and takes delight in, light from a face ten inches away, or from a star so remote that both distance and time begin to measure the same stupefyingly vast quantity. During these brief, intense moments, an aching sense of mortality rapidly alternates, even coexists, with the disembodied, godlike perspective of clear sight: at such moments *life* appears as an unfractioned, dizzying whole.

In the face of such a sight, photography (as I practice it) is hardly different from simple seeing; the picture is just a detailed form of the eye's plain version—a durable form that can be put away for later. Not much *making* is involved, though care and effort are needed to catch the sight before it changes, the sight that prompts the insight. A half smile forever on the brink of fading or flowering, a questioning glance whose puzzle will never be resolved, a hard stare that can never relax: these will never change, however much my link to them may change over the years I keep these bits of silent, stopped time.

Imagine a diminished ego, a self with so little selfhood it can hardly take a point of view without relying on a glass optical device. Imagine the passivity of this incomplete person, more aware of his senses' report of the world than of the need or value of strategies to negotiate and use it. A flimsy being pressed down by the huge weight of unfiltered actuality, this shadowy presence—imagine this too—is yet able, sometimes, to rise and take flight in a lurching, improvised stumble toward a dimly perceived but strongly desired goal: Truth, or the small part of truth that an anti-Ciceronian expression, dense in detail and clotted with conflicting meaning, can convey. Imagine such a self, and the things it might show and say, and you begin to picture the true ambition of this odd work.

3

DISTRUST OF THE SENSES has a long history. For 2,500 years at least, rigorous thinkers have repeatedly questioned whether the senses could report anything true, or even of great importance. A master of the subject could call as witnesses an almost complete alphabet of eminent names, from Augustine (and some passages in Aristotle) to Zeno. The roll call would linger in the P's: Parmenides, Plato, Pythagoras. Immanuel Kant called the most insistent among these thinkers, as a group, *intellectualists*. They share the belief "that the senses are *the parents of illusion*, and that truth is to be found in the understanding alone." According to this line of thought, the senses—including the eye—report the particular instance only, the anecdotal, the fortuitous: local color, what Parmenides called "the way of false-seeming." The understanding must weigh and interpret or even reject altogether this sensational reporting, this yellow journalism of the senses.

Only recently—over the last few centuries—has concentrated, isolated looking been widely accepted as a way to get to know about what we call the world. Perhaps coincidentally, perhaps not, photography has been around for the most energetic period of this ocular specialization (corrective eyeglasses and printing have been around longer). From the beginning, *especially* in the beginning, photographers wanted to make careful records of the objects and scenes their lenses projected. The adjective *photographic*, paired with the noun *likeness*, quickly came to define the extreme measure of accuracy. This definition acknowledged an increasingly common belief that *what was important to know about* and *what was there to be seen* were the same. A separate essay—a long one—would be needed to discuss whether this development has been an unqualified good to be described as "progress."

Photographic seeing, the kind of seeing practiced and valued by se-
rious photographers, was synonomous with careful looking, the kind of
visual inspection that notes tiny differences in appearance and attaches
significance to them—was, that is, until the last decade or two of the
century just ended, when art photographers in increasing numbers
began relying on captions and other conceptual strategies at least as
much as upon careful seeing. Nevertheless photography, for most of its
history, has been a medium of the eye. Painting and drawing require a
trained wrist and hand, but photographers depend on their eyes, and
usually on one eye more than the other.

*Photographer's eye, disembodied burrowing eye, seeing-eye men, the
strongest way of seeing, staring straight down a stack of decades*—such
phrases turn up regularly in the twentieth-century literature of pho-
tography. The twentieth was a century awash in eye images; they show
up everywhere, and not just in the literature of photography. Exactly at
mid-century, five years before his death (and five years after my birth),
Wallace Stevens published a long meditative poem that opens with
this pronouncement:

> The eye's plain version is a thing apart,
> The vulgate of experience.

"An Ordinary Evening in New Haven" is a big, majestic poem, a poem
remarkably full of images concerning *looking* and *the eye*. In singling
out, at the outset, *eye's version* and linking it with *experience*, Stevens
makes a connection any photographer who wants to trust seeing could
love. The inclusion of *plain* and *vulgate* makes the proposition more
intriguing still: the most direct, least digested report of experience, of
everyday life in the world, is translated for most of us—for the com-
mon observer—by the eye. The sound of the word *vulgate* sticks in the
ear a little—*vulgar* and its modern connotations are dragged into the
reader's mind along with the technical meaning of *vulgate*, common

language—but this note registers minimally, like an unnameable shape on the fringe of the field of vision, as the reader takes in the sense of the opening two lines.

Their statement is emphatic, as emphatic as Augustine's unqualified assertion that *truth lives in the interior man*. Coming at the poem's very opening, Stevens's bald assertion would seem, at first glance, to give the seeing-eye men and women, the practicing photographers, an inside track in any race for truth. If *truth* is (as a student paperback dictionary explains) the *real state of things*, most of us—those who are sighted—learn about this truth with our eyes, in the common language of sight we all share, Stevens seems to say. In saying this, he gives poetic voice and the flattery of his attention to a notion that would soon become a commonplace description of modern life. (*We are swamped with images; movies, picture magazines, cheap reproductions inundate us, etc.*)

A thoughtful, serious, major poet, at the height of his achievement, dignifies *plain seeing* by taking it as the starting point of his dense, gaudy meditation on the nature of reality. For one enamored of looking, this beginning is encouraging. But Stevens immediately—in the next line—qualifies his initial assertion:

> Of this,
> A few words, an and yet, and yet, and yet—

The repetitions imply more to say, further considerations, layers of meaning; they halt only on a dash, signifying ellipsis and some urgency, suggesting the possibility that a whole account can never be put down fully and clearly.

This suggested possibility only increases as the "endlessly elaborating poem" unfolds. *The eye's plain version* is soon joined, as a subject to be discussed, by "a second giant . . . A recent *imagining* of reality" (my italics). What has *imagined reality* to do with *the eye's plain version*? Quite a lot, it seems, as the poem goes on to another eye image:

"The point of vision and desire are the same. . . . desire, set deep in the eye, Behind all actual seeing, in the actual scene,/In the street . . . Always in emptiness that would be filled." *Desire*, and not just a capacity for plain seeing, is set *deep in the eye*. Desire, the mind's use and modification of *plain seeing*, must come to the aid of the "inexquisite eye," it seems, managing to see (in the black of night) a hill of stones as a "beau mont," searching out "such majesty as it could find." The eye's plain version emerges, in this poem, as the *beginning* of seeing, but not necessarily the *end*.

Although "We keep coming back and coming back/To the real," though "We seek/The poem of pure reality, untouched/By trope or deviation, straight to the word,/Straight to the transfixing object, to the object/At the exactest point at which it is itself,/Transfixing by being purely what it is,"—though we (we moderns) share a need or wish for certainty, to be able to see with an "eye made clear of uncertainty, with the sight/Of simple seeing, without reflection"—even so we find "metaphysical streets" in the "physical town," and leaves in whirlings in the gutters "resembling the presence of thought,/Resembling the presences of thoughts, as if,/In the end, in the whole psychology, the self,/The town, the weather, in a casual litter,/Together, said words of the world are the life of the world."

Thoughts have presences, are presences—present, but not visible to the eye's plain seeing. Already-spoken words—they and the thoughts they represent are surely not the objects of plain seeing; but now it is *as if* these words are "the life of the world." With this possibility before him, the reader can recall (and appreciate the full meaning of) the phrase *a thing apart* in the poem's opening lines. *The eye's plain version* is *a thing apart* not only in the sense that it is remarkable, to be singled out for special attention, but also in the sense that it is apart—away from—the center of things, the life of the world, the real state of things.

The poem introduces Professor Eucalyptus, who seeks God "with

an eye that does not look/Beyond the object." He seeks God "in the object itself," and he sees the object with an indifferent eye, an eye indifferent to what it sees. But in the end, we are told, it is the adjective he chooses for what he sees, the "commodious adjective" that counts, "The description that makes it divinity": "not grim/Reality but reality grimly seen . . ."

Thing and thought, world and mind refuse to stay separate in this poem. The poem's narrative voices engage a sort of peripatetic compromise, a necessary condition occasioned by the necessity of dealing with a world that presents houses composed of the sun but also composed of ourselves, houses *seen* in the sunlight, by our eyes, but also *known* (not to mention *judged, rated*), by our minds, in the black of night.

> If it should be true that reality exists
> In the mind: the tin plate, the loaf of bread on it,
> The long-bladed knife, the little to drink and her
>
> Misericordia, it follows that
> Real and unreal are two in one: New Haven
> Before and after one arrives or, say,
>
> Bergamo on a postcard, Rome after dark,
> Sweden described, Salzburg with shaded eyes
> Or Paris in conversation at a café.

The poem has strayed (or danced, with elaborate elegance) far from its beginning, the apparent certainties of *the eye's plain version*. Stevens was no professional philosopher, and his business in this poem is not to make logical argument for a single position and defend it. His business is to play at putting ideas into words, to try them out and see where they lead, to play the ideas (and the words representing them) off against each other:

The poem is the cry of its occasion,
Part of the res [thing] itself and not about it.

The poem is the cry of pain (or joy) itself, the *ouch* (or *hooray!*) and
not a descriptive statement that something hurts (or pleases). Stevens
is exercising a supple, well-furnished mind seasoned by fifty years of
thought on the subject at hand. His disciplined play gives a good in-
stance—not a report, but an instance—of how matters stood at mid-
century, and his is as good a voice as any I can think of to frame these
ancient questions in terms appropriate to my present day: not in terms
appropriate to Athens at the time of Plato, or to Germany at the be-
ginning of Romanticism, or to the rarefied discourse of an academy in
old Florence or New Haven, but appropriate to the living experience
of *my present day*, life as I live and know it.

The relationship of mind to world is neither simple nor clear. It
may be that there are answers:

A figure like Ecclesiast,
Rugged and luminous, chants in the dark
A text that is an answer, although obscure.

But the "never-ending meditation" ends, or stops, in uncertainty, on
this recurring note of *may be*:

It is not in the premise that reality
Is a solid. It may be a shade that traverses
A dust, a force that traverses a shade.

Such questions perplexed the poet in 1950, as he sat in study or office,
or over a martini at the Canoe Club, discussing the weather; they per-
plex the looker at the beginning of the new century as he walks the
streets, shuffles through his pictures, stares past his martini at late, low
sunlight on trees and hills. Over the course of the poem's meditation,
Stevens considers not only the thing seen but also the seer's mind and

his ambition, as well as the goodness or badness of the things seen, and other questions well apart from plain looking. He alludes to, reenacts the intellectual gestures of some of those thinkers who turned away from the plain report of the senses to the constructions of their own minds. *Looking* is where he starts, but perception, judgment, thinking, and *imagination* are never more than an image away.

As the repetitions and dash in the poem's first verse paragraph suggest, the simple assertion that *plain sight* equals *truth* does not stand unchallenged for long. In this, the endlessly elaborating poem parallels the experience of looking, at least as I have come to know it: alas. And alas, the subject I intended here—Eighth Street's changing urban fair and the experimenting young visitors it attracts—turns out to be multifaceted, offering many elements, each of which can be looked at (singly or in combination) from different points of view, and in different lights; the business of looking itself can be conducted variously: with different levels of attention and skill, for different reasons, and with different ends in view, focusing now on the thing seen, now on the seeing self, at still another *now* on the act of seeing itself. The eye's version—looking, as well as what is seen—is a thing apart indeed, a complex, privileged thing about which a few words, even more than a few words, might (and must) be said.

<div align="center">

4

</div>

A PHOTOGRAPH shows the illuminated surfaces of a collection of things, and only those surfaces facing the camera's lens, and those surfaces only as seen from the single point of view of the camera's lens (a human viewer must close one eye to approximate the camera's view). These surfaces are projected by the lens onto the flat film, where they become planar shapes which abut and overlap. The film-holder in the camera body or back arbitrarily frames the view taken, admitting to the

unshielded surface of the photographic film everything projected within the holder's opening, and excluding everything projected without, which—though present before the lens at the same time—does not become a part of the picture. The same is true of all aspects of the looked-at things that happen to face away from the lens at the moment of exposure. If *the eye's plain version*—even when taken in combination with data from the other senses—can be challenged as an adequate understanding of reality, how much *less* adequate is understanding gained through the qualified, attenuated kind of seeing we call *photographic*?

But photography is not simple seeing alone, not just the eye's plain version. The photographer who takes the picture chooses the things in front of the lens (or most of them at any rate; some he may not notice at the instant of exposure), the shapes their projections make in his picture, their overlappings, and the frame that surrounds them to edit them out of the flux. His (I am writing from my own experience) decisions are based in part on the shapes he watches, and in part on what these shapes and the things they represent mean to him. To use Stevens's terms, his composition is in part of the sun and in part of the mind: in part of seeing and in part of thinking.

When a certain kind of photographer—until about 1980, the most common kind of photographer—goes off to work, he walks out into the everyday world: not into a quiet study or studio but into an average landscape, perhaps to walk down an ordinary street in an ordinary town. As he goes about the business of picture-making (perhaps *picture-finding* is a more accurate term), he never has all the elements of his picture-to-be laid out before him on a worktable. He never sees neatly arranged for his consideration a checklist of the individual components of seeing, an index of the elements of significance, and a description of the effect he hopes his picture will have on the viewer. He cannot assemble them as you put together a puzzle or model kit. There you have a set number of pieces, you see them all in advance,

and you know they fit together to make a whole. The photographer finds these elements only bit by bit, as he goes, and he is never sure he has all the pieces, or whether the pieces he has can actually fit together at all. He finds his way as he goes—goes down the street, and goes through his life of work, in time coming to see significance where none was earlier, and formal possibilities in situations that once seemed intractable and confused. He finds his way as he goes, making whatever sense he can of what he sees—not unlike Lear on the heath, who meets a miserable wretch and imagines the poor creature's unhappy lot to be the result of thankless daughters.

The vision a photographer comes up with, whether he ever understands (in a way that would allow him to explain) the significance of all the elements he juggles during his years of active practice or not—this vision represents a union of *mind* and *world*. He need not settle for mere glimpses excerpted from the random daily flux of sensation. He need not content himself with "insulated facts," specific notations each collected separately, for the sake of its individual charms only.

He can try for more. The best he can hope for is a thing caught in an instant, but a thing caught by a mechanism purified by time and practice, a multiessential distillate drawn from the reaction between a persisting, struggling, improvising, perceiving mind and the close-watched facts of a visible world. The *short time* it takes to catch a picture contrasts with the *long time* the photographer pursues his subject in general. This longer time is the span of a career, to be measured in years, enough time for his interests and understanding to richen and mature. A web of connections gradually accretes—connections with the many things seen (including pictures), with things learned from experience (including the experience of reading), with things earnestly hoped for or feared. This web of connections expands over time, providing the photographer with a latent fund of reference, a kind of personal library. At his best moments, this individual culture is at the

ready, available to be drawn into play in the *short time*—in the brief period when a picture is sensed, framed, and snapped—drawn into play by the sudden appearance of some specific sight, a detail as small as a chipped nail, or the beginning of a frown line which suddenly appears in a certain slant of light. The specific detail, like the grain of dust on which a raindrop or snowflake begins to condense, prompts a miraculous kind of crystallization as all the elements of the visible scene pull themselves into some comprehensible order.

The *shortness* of this short time is key. During the few seconds between the initial recognition that something is there and the instant of exposure—for some photographers this short time can be astonishingly short, no more than a tiny fraction of a second; for me it stretches out to a minute or two—during this brief time the associations rush in and jostle for position all at once. The elements of seeing—distance, framing, angle, perspective, juxtaposition and arrangement of tonal value—say one thing, more likely many things; past memories, references to actual or fictional events, tags of verse, formulated ideas, recognized traits of character, information from a thousand other directions all say many other things. The storm of thought (and feeling) swells until the shutter clicks, when all is set down, the picture made. Sometimes, in the presence of an especially strong stimulation, the photographer keeps making more exposures, even after he thinks he already has it, even as he sees the coherent moment dissolving, as if the effort he exerts, his attempt to throw *more time* (the time it will take to print and edit all the film he is exposing) at the crystallizing scene that attracted him so, as if this willful exertion could hold the vision a little longer, or bring it back.

The *best the photographer can hope for* is to have this web of connections stimulated, brought into play, and sucessfully deployed around some specific sight, some tiny bit of bedrock seeing able to support the associations that rush in, able to ground, hypostatize, *stand*

under the elaborate superstructure of association and reference his mind constructs not *deliberately*, according to some plan or outline formulated at leisure, but *immediately*, on the spur of the moment, *because it cannot do otherwise*. The best this photographer can hope for is a *thinking*, an action of the understanding but one firmly grounded in the particular things whose surfaces his eye reports, a thinking that begins with looking.

Thus far my argument has been jumping around somewhat. I began with a preliminary look at a subject, went on to my own experience of that subject, which has been primarily visual, and then digressed to consider the validity of the *visual* as a proper mode of knowing at all. Just now the argument is at a delicate point: what I have said so far may seem to suggest, to some readers, that careful seeing is *less* than thought, and that at its best seeing might hope to come near the level of achievement available to thought. This is not the conclusion I want to suggest.

I have relied on Stevens because of the delicate balance—the peripatetic compromise, as I have called it—between the senses' report and the mind's construction his writing embodies. But my aim—the true ambition of this odd work, as I have said—is to go a little further than Stevens's equanimous balance. To clarify as well as recapitulate, let me suggest that thinking which depends on and is possible only after close looking, after careful, detailed observation, is different from thinking or understanding carried on in the absence of, or with a sense of the lesser importance of, such looking. *No ideas but in things* comes closer, perhaps, to the direction I intend.

Paul Oskar Kristeller observed that, before the nineteenth century, most writing on the subject of aesthetics was by amateurs—observers who regarded the process of artistic production from the outside, as appreciators rather than as producers. Let me now suggest, as a practitioner rather than as a spectator only, that an understanding—a think-

ing—grounded, based, dependent on *close looking* may have a reach and penetration different from thinking based only on reason, on deduction, or on statistical analysis. Kant tended to view the mind as a well-run university, with its various faculties each attending to its own proper function but able to cooperate from time to time. Following this appealingly understandable (if somewhat dated) model, let me suggest the possibility that *perception* (a part of the *imagination*), when it cooperates with, even directs, the *understanding*—when these two work in alliance, a kind of specific, anchored awareness, an awareness rooted in (but, thanks to the imagination, not limited to) the particular, is possible. This awareness—an understanding—surpasses (in some respects at least, those of reach and penetration) the kind of thinking available to reason alone. Thus the thinking of Flaubert, say, or of Stendhal—or of Walker Evans—at their best has a quality not accessible to the thought experiments of Descartes, however thrilling, even epoch-making his thinking *in its own right* is, or to the statistical analyses of demographers.

By 1929, Edmund Husserl was able to refer to the notion that things have existence apart from the perceiving mind as "naive Objectivism." A kind of direct, seemingly impersonal visual investigation launched about the same time, by artists including photographers, took the name *New Objectivity*. Like Stevens, the artists who joined in this movement were not philosophers but practitioners. My argument is that these, and those of us who follow in their wake, make a point. *Only thinking*—pure reasoning that has trouble paying sufficient attention to the referent of its propositions—is as limited as *only looking*, the visual athleticism tagged by Marcel Duchamp with the dismissive adjective *retinal*. *The thing itself*, a thing all but beyond the range of logical proof of Kant, just might lie within the focus of a lens made by Goerz or Zeiss, in the hands (and to the eye) of a thoughtful practitioner who values seeing.

5

THE QUALITY OF THE LIGHT ITSELF is never, or almost never, the actual subject of a picture I might take. Response to the light, observation of how it strikes and what it shows, and how it can be used to see and photograph, urges the act of looking to pay attention to the specific and unrepeatable, and to credit the unique. To an observer who looks closely enough, no two things are ever exactly the same, and to a practiced observer who values this truth, the sight of a human face at close range in its perfect light is a happy accident, a rare perfection like a complete double rainbow in the west at dawn that lasts for a few seconds only, though a clear photograph might hold it a dozen decades or so, or until an ability to see the wonder in it has passed from the range of human experience.

On overcast days, the light on Eighth Street falls gently from above. After passing down into the canyon to street level, it gives a soft overhead illumination, like light from a high skylight in a large windowless room. Often a brighter accent comes from a patch of unblocked sky visible through a break between buildings at the east or west end of a block, adding a gentle highlight to one side of a forehead, nose, or jawline. The resulting mild brightness is not so different from the light recommended by Leonardo da Vinci for viewing portrait subjects. In the *Treatise on Painting* he suggests a courtyard with high walls, one of which should be a little lower than the other three, to give a light that is soft but with some direction. He suggests viewing at dawn or dusk, when the light is softest.

A face viewed in this Leonardesque light looks gently volumetric — the soft shadows under brows, nose, and chin suggest the volumes that produce them without introducing any distracting hard-edged shapes of their own. Further, in soft light the human, psychological presence of the face is unaffected by the light in which it is observed: strong sun-

light causes most people to squint or look away, simplifying their human presence to that of an animal avoiding a painful sensation.

Not long ago I watched, in this kind of overcast light and at close range, the face of a young woman about eighteen or twenty years old. She was thin, and her hair was pulled away from her face and pinned up in a negligent way so that the shape of her face and head were clearly discernible: a modeled spheroid perched on the thin stem of her neck. In the soft, forgiving light, this impression of volume was not diminished by the state of her skin—her facial pores were large and clogged; indeed she was in general begrimed and smudged to an extent I would not have thought possible on a paved city street. Her upper body was covered by a faded green-tan T-shirt, also smudged, with an outline of the state of Arkansas and the words ARKANSAS GIRLS STATE on the front. Girls (or Boys) State, I remembered from my own school days in Texas, was an annual gathering of the most civic-minded, well-adjusted, and ambitious of a state's high school students.

She carried no hand or shoulder bag; I watched her pass on the street several times without managing to guess what condition of life her appearance might indicate—dropout? runaway? anarchist? suburban shopper? When I spoke to her she turned with directness and attention, her head round and prominent in the soft light, until her face, atop a thin neck bare except for a heavy chain of gold, was directed straight toward mine. Through one side of her lower lip she wore a thin, delicate ring of gold wire no more than a millimeter in diameter; its polished brightness contrasted with the dull matte skin of her face. Her expression was not hostile or even guarded, and in the soft brightness her eyes were prominent, large, luminous, bright as the gold she wore. Her look was steady and open; she regarded me (and my camera) with a gaze as unclouded as if she were listening to a friend, or looking at some trinket that caught her notice for a moment. Any ironical attitudes suggested by her dress and appearance were not apparent during this brief exchange with me: she was alert, attentive, and polite,

wishing me, as she turned to go, good luck with my historical project (the reason I gave when she asked why I wanted to take her picture).

Light on overcast days can be not just soft but dull, causing pools of shadow to gather in eyesockets and under chins; formal features are not always clearly delineated. This particular picture, it turned out, was too grey and unemphatic to give an adequate account of the presence I saw. Soft shadows became patches of smudge, and luminescence faded to dullness without concentrated deep blacks to act as tonal foils.

The presence of sunlight, even when it does not strike a subject directly, makes for livelier viewing. On clear days in winter the sun is far south in the sky, and shafts of cold hard light shoot up the avenues that intersect Eighth Street. Brilliance blasts through the intersections, but the southern sidewalks and most of the street remain in a shadow that is particularly deep on clear days. The wall of façades on the north side of the street is often in brilliant sunshine, however, and reflected sunlight enlivens the soft gloom of the southern side of the street. The reflected light comes at a face, it seems, from all directions at once, opening up areas of deep shadow but with a brilliance sufficiently weakened that it does not alter facial expressions in the way that direct sunlight does. Such light gives faces a luminous quality, and photographers with a mystical bent have described this kind of light as appearing to come from *within* the face rather than reflecting off its surface. Early observers of the night sky made the same error in describing the moon and planets.

The difference between reflected sunlight and dull overcast light has, in addition to its visible component, a strong animal element, at least for me. Even if what I see is not in the sun or in reflected sunshine, the fact that the sun is shining that day increases my appetite for looking and makes me feel more aware, more alert, as if the unfiltered sun somehow contributed a charge of raw energy to the whole enterprise, an energy lacking on cloudy days.

One February fifteen or so years ago I was sent to photograph some sculptures near Tulsa, Oklahoma. My part of upstate New York had had snow cover since late November that year, and overcast days had been common. There was as yet no hint of spring, and the colors that showed in the frozen landscape were browns and neutral greys.

I arrived in Tulsa at night; next morning I left a downtown hotel early, riding in a taxi to a place just outside town, a small museum. I saw it was clear, but the sun was still low, and my mind was full of equipment, filtration requirements of the color films I was using, possible views of the sculptures, and the other concerns that go along with this kind of work. Later that afternoon, when I left the windowless studio I was working in and stepped outside to go back to the hotel, the brilliance of the mild day struck me like a blow.

The sky was cloudless, but the day was warm enough—I think the temperature was in the 50s—so there was some humidity in the air: not a haze but just enough moisture to soften and diffuse the sunlight a little. The sky was blue, but more of a blue-green, not the deep, cold blue of the winter sky in New England. It was paler, and the color lightened toward white near the horizon, where this sky met the gently rolling Gilcrease hills, a dry landscape with few large trees and low, scraggly ground cover. At this time of year the vegetation was still subdued by cold, but it had color: traces of green and gold were clearly visible within the neutral tones. The softened light struck gently, not hard and glaring like a Northern winter sun on a 10-degree day, and the ground looked soft and plush, fuzzy rather than metallic and hard.

My view of this scene then was not as analytical as it sounds here: all its components struck me at once as ensemble. After a day of looking at hard bronze lighted by electric floodlight, I was especially susceptible to the lush early spring tableau outside. The soft golden light and the gentle, textured landscape struck me with palpable force, though I had not come there to see it and had no plans or even interest to photograph it. I was simply ravished and momentarily taken out

of myself by the sight. Sunlight can do that, even when it is not a tool for immediate use or a necessary component of the task at hand. Conrad's narrator Marlow says he prefers the gloomy comfort of a cloudy sky at night; seeing the stars, he says, reminds him too forcefully of the immensity of the universe. It has always seemed to me that the unveiled presence of the sun has just the opposite effect: to make small individual things and petty anonymous forgettable human individuals distinct, noticeable, worthy of attention, striking, more interesting. Perhaps it is the emphasis on looking, rather than brooding, that makes the difference, the difference between night thoughts and day thoughts.

6

IN SUMMER the sun's course is far to the north, and Eighth Street, on sunny days, is awash in sunlight from six in the morning until nearly 8 P.M. The light is particularly active in late afternoon (and in early morning too, though I have never watched early morning light here). Late in the day the sun begins to sink behind the gap-toothed skyline of the city, sending shafts of brilliance that play like theatrical spotlights across the city's eastern parts. Also in late afternoon in summer, pedestrian traffic on St. Mark's Place picks up as the heat of the summer day begins to moderate. At this hour the street and its sidewalks are frequently jammed with hundreds or thousands of walkers and shoppers.

Earlier in the afternoon, though, especially on hot weekdays, streets are often uncrowded, and the sun is high overhead, its brilliance kept from the sidewalks by the foliage of the trees growing along some blocks. The light under their boughs is soft, almost as dull as on overcast days, and it changes little from minute to minute. In midday

a single observation can last a long time without a noticeable change in the light.

The block of St. Mark's between Third and Second Avenues—the block that can be called the heart of street life on Eighth Street—is planted with mature ginkgo and locust trees, and in midsummer, when these trees are in full leaf, the sidewalks are in shade for most of the midday. One shop there displaying clothing and accessories (along with a sign advertising a body-piercing special, forty dollars including jewelry), in the basement of a row house, is almost hidden even from this dull light by a large iron stoop rising to a parlor-floor entrance. The stoop is flanked by concrete steps leading down to the basement entrance, creating a small concrete plaza shaded by the stoop as well as by the trees nearby.

During the summer of 1997 a store clerk, a woman in her early twenties, retreated to this shady spot eight or ten times an afternoon most days to sit on the concrete steps, lean against the metal stoop, and smoke a cigarette. She was almost my height—she was maybe five feet eight or five feet ten—and lanky, with very white skin—it seemed never to have come in contact with the bright sunlight so visible on Eighth Street in summer. Her hair had I think originally been dark, but now it was dyed the dead black preferred by many punks. Over a period of several weeks it displayed the same highlights, flashes of vermillion and dark green, and it was teased and matted into a mass resembling dreadlocks, but not as orderly. Bits of ribbon were woven in, but the effect was not gay—the colors were too dark and the mass of hair too formidable. Rather, this huge hair added to the wraithlike appearance of the girl's face.

The skin of that face was as rough and ruddy as the rest of her skin I saw, that covering arms and legs, was white and smooth. She wore some dark makeup around her eyes and several pieces of piercing jewelry—cheeks and lower lip, I think, and maybe earrings as well, but

these additions did not shield or mask her face so much as did her usual expression, or rather the ground state of her face, its basic attitude, the cast that is the basis for all expressions that could fit on that face. In a word, it was closed; the pattern of her features always seemed to me to suggest something like pain or annoyance, some unpleasant stimulation, and her eyes were almost always in a squint, making them impossible to see into. When I watched her face, even from a close distance, it was like a shut door, a mask of tight features surmounted by a fright show of tangled Gorgon's hair. She had the aspect of a fury.

Her movements had a jerky quality suggestive of barely contained energy liable to explode with little provocation. One afternoon I watched as she arranged and rearranged a mannequin in the shop window. She would look from the concrete plaza, go in to adjust an arm or head, and then come back outside to look in at what she had done, standing with hands on hips, weight on one leg, and head cocked to one side. Then she would shift her weight to the other leg abruptly and cock her head the other way at the same time. This day she had on camouflage pants rolled up to the knees, showing a tattoo above one ankle visible just above the strap of the heavy Mary Jane shoes she always wore without socks, and her top was covered by layers of sleeveless garments, the outermost of which was styled like a men's undershirt and bore, on its front, a severe stylized black eagle on a shield, with outspread wings and head turned in profile: a Teutonic crest with the legend *Bundeswehr*. Her overstated jerky movements and elaborate getup suggested a performance of some kind, but I was standing at some distance, and there was no one else nearby—it was still early afternoon. She kept on rearranging and looking, popping in and out of the shop and tossing her arms and head about, sitting on the steps once or twice for a smoke, until the window display pleased her.

Although I looked for this wraith every time I was on the street that summer, and though she spent a good deal of time outside the shop, I

rarely saw her talking with anyone. One afternoon she had a visitor—
a young man about her age, heavy, and with a mass of light-brown hair
teased and matted like hers, though his costume was different. That
day she wore an underwear-for-outerwear getup, a black lace-trimmed
knee-length slip, while he had on olive-drab pants, not baggy enough
to make a statement, with a yellow T-shirt, no crest or message.

She sat on her usual spot as he stood next to her, and she put her
thin white arms around the bulk of his middle and looked eastward up
the street, her expression for once peaceful, almost wistful. He fingered
her teased hair in an absentminded way, and they stayed there without
talking for several minutes. The scene was surprisingly serene: she
didn't jerk up and down or smoke, indeed hardly moved the whole
time.

Eventually he sat in her spot and she stood up, talking with ani-
mation and resuming the jerky posturing I had seen before. He play-
fully poked at her stomach with one finger, and she smiled or rather
leered—I was again aware of the hardness of her face—pivoted, and
(her back now toward him and also toward me, across the street behind
him) thrust her thin, black-clad bottom in the direction of his face,
looking back at him over her shoulder with the same hard smile. This
gesture became a dance performance as she turned her profile toward
her audience and executed a series of rhythmic pelvic movements sug-
gesting canine arousal accompanied by abrupt pulling movements of
her clenched fists. A moment earlier I had been thinking of a tender
high school interlude, a kind of Lower East Side Story; suddenly I was
in a Pigalle nightclub or a Berlin cabaret.

The audience's back was toward me, so I couldn't see his response,
though it involved no movement I could see. After half a minute the
dance stopped, and she went inside, back to work I guess; he stayed on
the steps waiting for her to come out again, which she did from time
to time as the afternoon wore on.

By late afternoon I was drawn to look at other things. The day was clear, and the sun was moving down in the sky; as it lowered, the light became more active and more specific. A little story evolving over time now seemed of less interest than ephemeral tableaux, brief little scenes ignited by a fleeting perfect light rather than the promise of some sustained narrative.

By 4:30 much of the street is in shadow, and shafts of brilliance from the west begin their play of light and shadow. The huge bulk of the original Cooper Union building cooperates with buildings farther to the west and a row of mature plane trees planted across the street (in front of the newer Cooper Annex) to frame a shaft of light that begins, about this time, to enter the gloom of an open-front bar on the east side of Third Avenue, two or three doors up from St. Mark's. In warm weather the bar's entire front is open to the street—a black gap among the sunlit storefronts, a darkness illuminated only by a few amber sconces and a color television over the bar until the late afternoon sun begins to creep in.

For a while a canvas canopy projecting over the single door that is the bar's year-round entrance blocks the light, but eventually—sometime after five o'clock in late July—the sun sinks low enough to penetrate under the canopy and into the dark interior of the bar. At first it strikes the floor, scattering reflected brilliance on the undersides of chins and under eyebrows, upward toward the ceiling, an inverted daylight like the sunlight reflected up from water through blinds to pattern the ceilings of shuttered palazzi in Venice.

Then the shaft of light begins a climb up the barstools, and (one Friday several Julys ago) up the legs of a single customer, a Latino sitting with his feet on the rungs of the tubular chrome stool, lifted up as if to avoid the pool of light on the floor, his upper body leaning over on the bar. Shiny jet hair emphasized the lightness of the skin of his face, whose thickish features were directed outward, toward the side-

walk glare, but he seemed not to be looking at anything. His face registered something like disbelief, or mild shock mingled with some pain, and it was agitated. While his arms and hands made small, slight movements too rudimentary to be called gestures, his head moved slightly as well, as if some silent dialogue with an imagined interlocutor provoked emotions so strongly felt, so iceberg large (so to speak) that their tips broke through the surface as vestigial motions of a troubled mind.

As he sat absorbed by an interior reality that shut him off from outward sight, the sunlight moved steadily up his leg, above the belt, and onto his powder-blue shirt, brilliant now against the blackness behind it. But the midsummer sun as it sets moves back to the north, as well as down toward the horizon, and the particular shaft—the shaft framed by Cooper Union and the plane trees to the north—of brilliance that was lighting this little drama was moving downtown, or south, as the sun moved north in the sky. Before the sun reached the man's troubled face it disappeared into the plane trees along the north side of Eighth Street, and the full brightness slid south to an empty table near the canopied single door, across the front of a pizza shop, and on to the music stall next door. There a large black man sat facing out, now in full July sun, a huge electric fan half a foot from his right ear, mouthing the words to the rap CDs he played, at some volume, to advertise the goods stacked inches behind him in the shallow stall.

After six the light changes pretty quickly; within minutes the bar opening was in shadow and the sunlight was passing downtown from the DJ supplying the sound track for this scene to the pay telephone on the corner, where for a few minutes anyone making a call found him- or herself in a spotlight that would show, to anyone who looked, the exact point around the ear where foundation makeup applied to the face feathered out to reveal bare skin, or the small shadow defining

157

the low relief of a swollen fresh tattoo, and the glassy sheen of the antiseptic salve covering it.

In mid-July this particular shaft of light moves farther south still, leaving the Third Avenue façades altogether and blasting down the north sidewalk of St. Mark's Place, where it breaks into patches of raw sunlight whose edges are shaped not only by the edges of buildings many blocks to the west but also by the ragged edges of leafy boughs directly overhead. These patches of light change quickly, now lighting the face of one member of a couple at a sidewalk café, and next minute the back of the head of the other, and then a few minutes later just the side of a face on the stoop above.

A little after seven o'clock this particular set of the light show ends: all the sidewalk from Third to Second Avenue is in shadow, and the sun retreats to the upper stories and to a huge portrait painted on an exposed western wall. In mid-July, though, a spectacular finale takes place after seven, farther east, between Broadway and Lafayette. After sinking beneath the top edge of an apartment tower, the sun, moving northward, breaks out from behind the tower into clear sky sending (at this hour, for a few midsummer weeks) a late shaft of light that bathes the entire north sidewalk in sun, and even reaches across the street to the south side of the street. For several minutes a narrow triangle of pure sunlight spills just over the curb and onto the south sidewalk. I saw this brief illumination just once in 1997: during its appearance a young skateboarder, a Chinese girl, was walking east, probably from Washington Square Park where I had seen her skateboarding a few days earlier. She walked west from Broadway, carrying her skateboard in deep shadow, and then she passed suddenly into this thin wedge of pure sunlight. For two or three seconds the sharp light picked her receding figure out from the large mass of shadow looming ahead, and I could see, clearly delineated in the hard light, the rubber bands holding her hair into many separate small clumps, her golden-tan skin, the

pastel-yellow broad-patterned plaid of her sleeveless shirt, the olive-drab fatigue pants with one leg rolled up, the scuffed white sneakers worn without socks, the garishly patterned skateboard she carried by one end, its length held down along her leg: her appearance the accumulated sum of dozens of volitional acts enacted over many hours of human time. Each act left its residue, visible evidence surviving unchanged until another act, or accident, alters it, each residue flowing forward in time to press up against the windowpane of *now, this instant*, to be seen in perfect light and for a brief second or two by me. Of the thousands standing or walking in Eighth Street that midsummer afternoon, only I was in the right place, at the right time, and in the right frame of mind to see that perfect sight. To take sudden possession of unique visible knowledge—to recognize it for what it is, not for what it can be turned into or used for—to savor and note such knowledge is one way of being fully alive. Stendhal would have called such a moment of vision *sensation*, and the force of it might have knocked that susceptible observer down in the street.

In a flash she was gone from my full sight, gathered back into the shadow, and a few minutes later the sunlight had retreated from the south side of the street. For several minutes longer this late shaft of undiluted light reached from the sun, low in the sky, down the whole length of the north sidewalk of Eighth Street from Broadway to Lafayette. By this time the rays are almost parallel to the sidewalk; when they strike a face they penetrate into the deepest eye sockets and into open mouths, under chins and beneath cap brims, leaving nothing facing west in shadow. A watcher standing at the corner of Broadway and Eighth, facing east, sees a steady procession of figures emerge out of shadow into brilliant spotlight, like projected slides flashing on a screen in a darkened room, or like figures photographed by flashbulb outdoors at night, the luminous apparitions that appear for 1/25 of a second and then vanish, leaving behind a stunned retinal impression

that can best be seen with the eyes closed, and perhaps also leaving be-
hind—if everything worked—a latent image recorded on a sheet of
photographic film.

Minutes later the sunlight begins to leave Eighth Street altogether.
For a brief time only the upper parts of figures are lighted, then only a
head here and there, and then the brilliance climbs the vertical walls,
up the slatted steel shutters of the truck loading docks, up the façades
of stone and brick, retreating to the treetops and upper stories. The
huge portrait catches the sun for a while longer, as late as the third and
fourth floors of some buildings, but the shadow continues its steady
rise, and soon only the upper stories of the tallest buildings are in sun.
Sometimes a high window sends a shaft of reflected brilliance back
down to street level, and a fleeting, weak pool of false sunlight casts
faint shadows for a minute or two, but the full brilliance is gone, risen
through the air and into the clear blue skies visible above Eighth Street
on such summer days, where it still lights a white cloud or a silver air-
plane.

Down below at street level, other lights appear. The windows and
open doors of restaurants and bars, black holes in daylight, now pour
their soft multicolored light onto the pavement. The cool glare of fluo-
rescent tubes fills a shoe repair and a barber shop, and vendors at side-
walk stalls turn on yellowish tungsten bulbs in conical reflectors to
light their wares. Car headlights cut through the deepening dusk—by
the late 1990s they too come in several hues, and beer signs in tavern
windows add their chromatic glow.

At this hour the street begins to change: nightlife begins. Many
come around only for this—late shopping, dinner, music clubs—but I
have never watched any of it myself. Most of the action moves indoors,
away from the public sidewalks, and the light is low and smudgy in-
doors as well as out. A furtive sidelong glance, not a direct stare, would
seem to suit this hour and this light; photographs made now should be
shallow-toned, grainy, and blurred, or else a blunt flashlit reconstruc-

tion of visible reality, the paparazzi's view. At night, sight loses its day-time dominance, and seeing sinks back in among the other senses and other ways of knowing, supposing, suggesting: a rich milieu, and fertile material, but for others. Daylight—God's sunlight, Holgrave the fictional daguerreotypist calls it—has gone, and its brightness, and the looking it stimulates, are over. I join the many other visitors who, at this hour, head for the bus station, the train, or the garage.

THE LIGHT ON EIGHTH STREET: PICTURES

1. St. Mark's east of Third Avenue, south side, 1987
2. Third Avenue north of Eighth, west side, 1987
3. Greene below Eighth, west side, 1985
4. First Avenue at Eighth, east side, 1984
5. Eighth east of Sixth Avenue, south side, 1984
6. Avenue A just south of Eighth, west side, 1985
7. Broadway below Eighth, east side, 1983
8. Eighth between Broadway and Cooper Square, south side, 2000
9. St. Mark's between Third and Second avenues, south side, 1999
10. Broadway south of Eighth, east side, 1997
11. In line at Gray's Papaya, Eighth at Sixth Avenue, north side, 1999
12. Eighth at Sixth Avenue, south side, 1998
13. In Cooper Square, facing west, 1998
14. St. Mark's between Third and Second avenues, south side, 2001
15. St. Mark's east of Third Avenue, south side, 1984

Afterword

FOOTNOTES and a formal bibliography would be out of place in a personal essay. The author has benefited from a number of books, essays, and other sources of information, though, and he wishes to acknowledge the use he has made of them. These include the following sources not mentioned by name in my text: M. H. Abrams, *The Mirror and the Lamp*; Hannah Arendt, *The Life of the Mind: Thinking*; Aristotle, *On Poetics* (translated by Ingram Bywater); Doris Bry, *Alfred Stieglitz: Photographer* (with an introduction by Perry Rathbone); Samuel Taylor Coleridge, *Biographia Literaria*; Northrop Frye, *Anatomy of Criticism*; Martin Heidegger, *Parmenides* (translated by André Schuwer and Richard Rojcewicz); Maria Morris Hambourg, Jeff L. Rosenheim, and others, *Walker Evans*; Judith Keller, *Walker Evans in the Getty Museum Collection*; Paul Oskar Kristeller, "The Modern System of the Arts"; Sue Davidson Lowe, *Stieglitz: A Memoir/Biography*; James R. Mellow, *Walker Evans* (with an introduction by Hilton Kramer); Edward Mendelson, *Later Auden*; Beaumont Newhall, *The History of Photography*; Nancy Newhall, ed., *The Daybooks of Edward Weston*; Jeff L. Rosenheim and Douglas Eklund, eds., *Unclassified: A Walker Evans Anthology*; Margaret Sartor and

Geoff Dyer, *What Was True: The Photographs and Notebooks of William Gedney*; Herbert Seligman, *Alfred Stieglitz Talking*; Alan Trachtenberg, *Reading American Photographs*; Stefan Zweig, *Adepts in Self-Portraiture* (translated by Eden and Cedar Paul); and correspondence or conversations with Paul Caponigro, Walker Evans, Thomas L. Heacox, John T. Hill, Nicholas Jenkins, Lincoln Kirstein, Frances Lindley, Nicholas Nixon, Tod Papageorge, Meyer Schapiro, Erik Wensberg, Minor White, and many others.

Although the observations and questions that prompted this book arose initially from my experience as a working photographer, the books, documents, and people I consulted gave me much information I could use and often directed me to sources previously unknown to me that gave me more. Every significant discovery enriched or clarified my initial notions and helped steer the meandering path the arguments of my essays have taken. As John Keats knew, rushing too directly to the point is sometimes a way of missing the point.

I am particularly grateful for the work of three writers. Lincoln Kirstein, Michael Roemer, and Theodore Weiss have gone beyond professional practice to write essays ranging not only across their individual specialties but over the full expanse of their culture. Without their encouraging examples I would not have attempted this book.

Index

Abrams, M. H., 165

Adams, Ansel, 60, 62, 68

Adams, Henry, 68, 73, 77

Adams, Robert, 9

Addison, Joseph, 83

Aesthetic idea, 84

Agee, James, 77

Ahab, 54, 65

American Monument, The
(Friedlander) 10

American Photographs, (Evans), 37,
77–83

"An Ordinary Evening in New
Haven," (Stevens), 137–142

Anaximander, 47

Antlitz der Zeit, 74

Ara Coeli, 68, 73

Arendt, Hannah, 165

Aristotle, 52, 56, 57, 58, 67, 136, 165

Atget, Eugène, 10, 31, 36, 45, 69,
89

Auden, Wystan Hugh, 93–96, 165

Augustine, 136, 138

Bachelard, Gaston, 28

Baudelaire, Charles, 38

Beaumont, Francis, 99

Biely, Andrey, 32

Bloch, Ernest, 62

Botticelli, 77

Bry, Doris, 165

Burroughs, Allie Mae, 39, 42, 46, 86

Bywater, Ingram, 165

Camera obscura, 3, 4

Canoe Club, 141

Caponigro, Paul, 52–66, 68, 69, 89,
97, 99, 166

Cartier-Bresson, Henri, 98

Civil war: photographs of, 47

Coleridge, Samuel Taylor, 6, 13, 47, 66, 129, 165
Concert Singer, The, (Eakins), 58
Coney Island, 126
Conrad, Joseph, 44, 152
Coomaraswamy, Ananda, 23, 47
Cooper Union, 156, 157
Cosindas, Marie, 35
Crane, Stephen, 33
Criterion, 31
Critique of Aesthetic Judgment, (Kant), 83–85
Custer, George, 81

Da Vinci, Leonardo, 73, 148
Daguerre, Louis Jacques Mandé, 4
Dedalus, Stephen, 19
Degas, Edgar, 57
Descartes, Rene, 22, 147
Duchamp, Marcel, 73, 147
Dyer, Geoff, 166

Eakins Press Foundation, 10
Eakins, Thomas, 58, 91
Eighth Street: architecture of, 129; character of light on, 125–126, 127, 148–150, 152–161; people in, 127, 130–131, 153–159; physical characteristics of, 125–126; shopping areas of, 128
Eklund, Douglas, 165
Eliot, Thomas Stearns, 13, 31, 97
Emerson, Ralph Waldo, 31

Endymion, (Keats), 13
Equivalent, 25, 63. See also Stieglitz, Alfred.
Evans, Walker, 8, 31–45, 47, 68–88, 89, 97, 99, 147, 165, 166

F64, 8
Family of Man, The, 75
Fancy, 13. See also Imagination.
Fitzgerald, Francis Scott, 129
Flaubert, Gustave, 31, 87, 97, 147
Fletcher, John, 99
Ford Foundation, 36
Frank, Robert, 9, 69
Friedlander, Lee, 10, 69
Frye, Northrop, 60, 165

Gedney, William, 89–97, 98, 99, 166
Genius, 85. See also Kant, Immanuel.
Gibbon, Edward, 68, 73
Gilcrease Hills, 151
Goerz, C. P., 147
Gray's Papaya, 163
Guggenheim Fellowship, 52

Hambourg, Maria Morris, 165
Harder They Fall, The, 93
Hartley, Marsden, 27
Heacox, Thomas L., 166
Heidegger, Martin, 46, 165
Heraclitus, 47

Hesiod, 91
Hill, John T., 166
Hirschfeld, Magnus, 95
Hound and Horn, 31, 32, 35, 40
Houston, Texas, 128–129
Husserl, Edmund, 147

Imagination (discussed), 13, 53. *See also* Fancy.
"In Praise of Limestone," (Auden), 93–96
Inscription Rock, 11
Insulated facts, 144
Intellectualists, 136. *See also* Kant, Immanuel.

Jackson, William Henry, 9
Jenkins, Nicholas, 166
Joe's Auto Graveyard, (Evans), 69
Johnson, Samuel, 57
Josephson, Ken, 71
Joyce, James, 31, 36, 41, 45, 97

Kant, Immanuel, 8, 83–85, 136, 147
Keaton, Buster, 44
Keats, John, 13, 86, 93–95, 99, 166
Keller, Judith, 165
Kenyon Review, 43
Kilterman Dolmen, 52
Kirstein, Lincoln, 31, 33, 40, 41, 77, 78, 166
Kramer, Hilton, 35

Kristeller, Paul Oskar, 146, 165
Kronenberger, Louis, 35

"Labor Anonymous," 70
Lange, Dorothea, 88
Life, 80
Lindley, Frances, 166
Logos, 69, 88
Looking: as a means of being fully alive, 159; as knowing, 136; in the twentieth century, 137; limits of, 136, 137–143; method of, 130–131; possibilities of, 143–147
Lord Elgin, 90
Lowe, Sue Davidson, 165

Main Street, Saratoga Springs, New York, 1931, (Evans), 80
Marin, John, 27
Medium (artistic), discussed, 11, 143–146
Mellow, James, 35, 165
Melos, 56, 57–62, 64, 66, 88
Melville, Herman, 31
Mendelson, Edward, 93–94, 165
Message from the Interior, (Evans), 35
Mill, John Stuart, 6
Mimesis, 55
Modernism, 27, 38
Morrell, Abelardo, 71
Mountbatten, Louis and Edwina, 98

Museum of Modern Art, 37, 77
Music, (Stieglitz), 62. See also
 Stieglitz, Alfred.

Nabokov, Vladimir, 13, 35, 98
Nehru, Jawaharlal, 98
New Objectivity, 147
Newhall, Beaumont, 4, 165
Newhall, Nancy, 165
Nixon, Nicholas, 10, 166
"Notes Toward a Supreme Fiction,"
 (Stevens), 94

"Ode on a Grecian Urn," (Keats),
 86
O'Keeffe, Georgia, 27, 29
Open Boat, The, (Crane) 33
O'Sullivan, Timothy J., 11, 12, 53

Papageorge, Tod, 60, 165
Parade, 56
Parmenides, 47, 136, 165
Parthenon, 90
Paul, Cedar, 166
Paul, Eden, 166
Pencil of Nature, The, 5–7
Penny Picture Studio, (Evans),
 69–76, 77
Phaedo, 30
Photography, materials and methods
 of: applications of, 20–21, 23–24;

improvements in, 20; initial
development of, 3–4; highest use
of, 12–13, 143–146; with large
cameras: deliberate point of view,
7, 26–27; manipulation of
exposure, negative development,
and printing, 54, 59–60;
operation, 39–40, 72, 132; with
small cameras: 14, 97, 132–133
Picasso, Pablo, 97
Plato, 30, 136, 141
Plotinus, 67
Poe, Edgar Allan, 21
Poetics of Space, The, (Bachelard),
 28
Pollock, Jackson, 98
Porch with Grape Vine, Lake
 George, 1934, (Stieglitz), 24–30
Print, The, (Adams), 60. See also
 Adams, Ansel.
Prometheus, 91
Pythagoras, 136

Quality: Its Image in the Arts, 35
Quinn, Anthony, 93

Rathbone, Perry, 165
Reinhardt, Ad, 61
Roemer, Michael, 165
Rojcewicz, Richard, 165
Romanticism, 6, 30, 38, 45
Rosenheim, Jeff L., 165

Rothstein, Arthur, 88
Ruskin, John, 4, 28, 33, 68

St. Mark's Basilica, 4, 126
St. Mark's Place, 126, 152, 153, 156, 158, 163
St. Michael's Cemetery, 37
St. Petersburg, (Biely), 32
Sander, August, 31, 70, 74, 75, 76
Sartor, Margaret, 165
Satie, Erik, 56
Schapiro, Meyer, 63, 165
Schuwer, Andre, 165
Scientific method, 45
Seligman, Herbert, 166
Shahn, Ben, 38
Sistine Chapel, 91
Socrates, 30, 78
Somer, Frederick, 61
Songs of the Sky, (Stieglitz), 62. See also Stieglitz, Alfred.
Spengler, Oswald, 70
Steichen, Edward, 7, 10, 21, 31
Steinberg, Saul, 34
Steiner, Ralph, 10
Stendhal (Henri Beyle), 87–88, 147, 159
Stevens, Wallace, 57, 94, 137–142, 143, 146, 147
Stieglitz, Alfred, 10, 23, 24–30, 33, 34, 37, 38, 39, 43, 44, 60, 62, 63, 88, 165, 166
Stieglitz, Kitty, 30

Stuart, Jeb, 81
Swift, Jonathan, 35

Talbot, William Henry Fox, 4, 12
Thoreau, Henry David, 31
Time: extending from now, 134; extending up until now, 159; long/short, 144–145; stopped, 132–135
Tompkins Square Park, 126
Tone: in Caponigro, 61–62; in Evans and Stieglitz, 32
Trachtenberg, Alan, 47, 166
Treatise on Painting, (da Vinci), 148. See also da Vinci, Leonardo.
Trilling, Lionel, 43
Truth: as accurate verisimilitude, 21; as actuality in depth, 36–37; as an imprecise term, 19; as artistic expression, 22; as beauty, 86; as correspondence, 22,23 (*see also* Equivalent); as fidelity to subjective experience, 22; as final play, the unbounded expanse and wealth of thought, 84, 87 (*see also* Aesthetic idea); as forging of experience into meaning, 99 (*see also* Imagination); as glimpsed in part, 135; as honesty of vision, 42; as identity of aspect, 21; as immediate sensation, 158–159; as modernist composition, 27; as mystical experience, 66–67; as

Truth (*cont.*)

present in the understanding alone, 136; as projection of the artist's person, 36; as radically unsettled indeterminacy, 86; as sure, thoughtful embrace of the physical world, 96; defined as "the real state of things," 138; open truth, 46; possibly lying within the focus of a lens, 146–147 (*see also* Photography, materials and methods of: highest use of)

Tulsa, Oklahoma, 151

Ulysses, (Joyce), 19

"Upon Seeing the Elgin Marbles for the First time," (Keats), 93–95

Van Gogh, Vincent, 98

Venice, California, 126

Venice, Italy, 28, 126

Von Gloeden, Wilhelm, 95

Warhol, Andy, 75, 98

Weiss, Theodore, 166

Wensberg, Erik, 166

Weston, Edward, 8, 62, 88, 165

White, Minor, 63, 64, 166

Whitman, Walt, 10, 31

Winckelmann, Johann, 94

Winogrand, Garry, 14

Winterreise, 56

Wölfflin, Heinrich, 64, 64n

Wordsworth, William, 6, 99

Zeiss, Carl, 147

Zeno, 136

Zone system, 63, 63n

Zweig, Stefan, 87, 166

A NOTE ON THE AUTHOR

Jerry L. Thompson was born in Houston, Texas, and studied at the University of Texas and Yale University. Since 1973 he has been a professional photographer, teaching for seven years at Yale and serving as Photographer in Residence of the American Wing of the Metropolitan Museum of Art from 1983 to 1985. He has also held fellowships from the National Endowment for the Arts and the John Simon Guggenheim Foundation. Mr. Thompson's pictures may be found in the permanent collections of major American museums. His other books include *The Last Years of Walker Evans* and, with Susan M. Vogel, *Closeup: Lessons in the Art of Seeing African Art*. He lives in Amenia, New York, with his wife and daughter.